Once a passionate natural scientist and with two science degrees under his belt, Ian Sheldon (Magdalene 1990) became distracted by the fine arts. Now a resident of Canada, he is a full-time established artist. Shows in San Francisco, New York and across Canada have cemented his presence in the art world, and have earned him a place in Canadian *Who's Who*.

Working in a number of styles and media, diversity keeps this artist highly stimulated and very productive. Some of his passion has been directed towards nature illustration and his work can be found on bookshelves throughout North America. Return trips to the United Kingdom and Europe continue to foster his passion for architectural watercolours, while wilderness forays fuel his vast prairie landscapes in oil.

All of his artistic undertakings can be closely followed on his website at www.iansheldon.com.

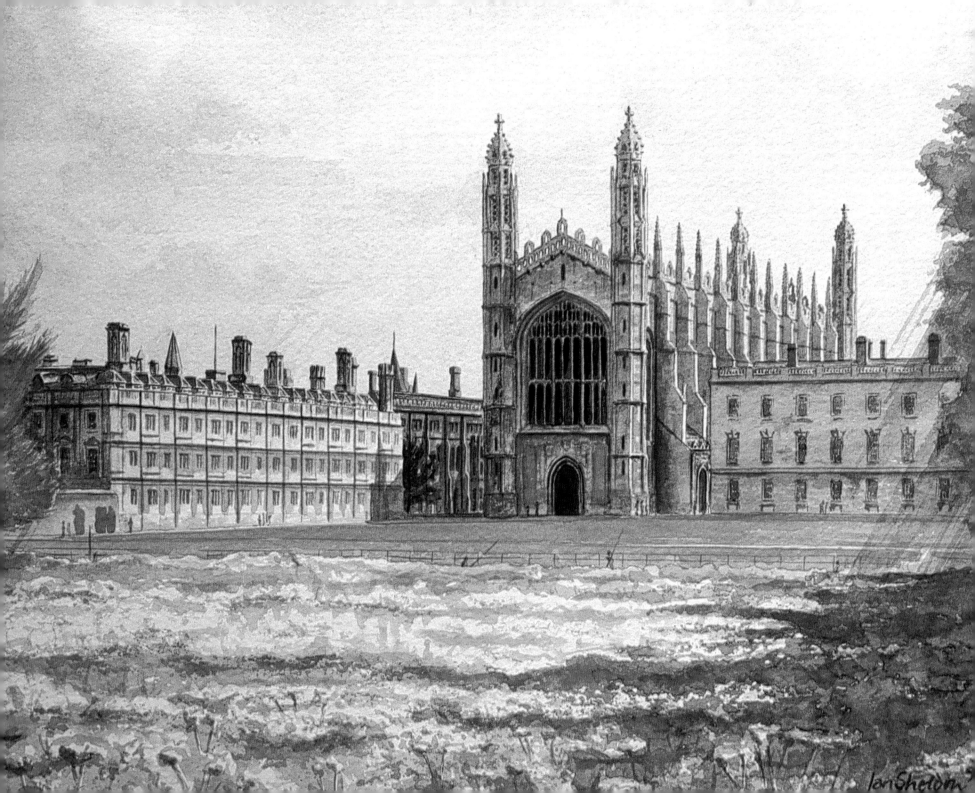

CAMBRIDGE FOOTSTEPS

A PASSAGE THROUGH TIME

IAN SHELDON

CAMBRIDGE
UNIVERSITY PRESS

CAMBRIDGE UNIVERSITY PRESS

Cambridge, New York, Melbourne, Madrid, Cape Town, Singapore, São Paulo

Cambridge University Press
The Edinburgh Building, Cambridge CB2 2RU, UK

www.cambridge.org

© Ian Sheldon 2009

First published 2009

Design, typesetting and layout by Phil Treble.
Photograph of Ian Sheldon on the half-title page by Darren Greenwood.
Printed in the United Kingdom at the University Press, Cambridge

ISBN-13 978-0-521-19721-2 HARDBACK

CONTENTS

SOUTHERLY APPROACH

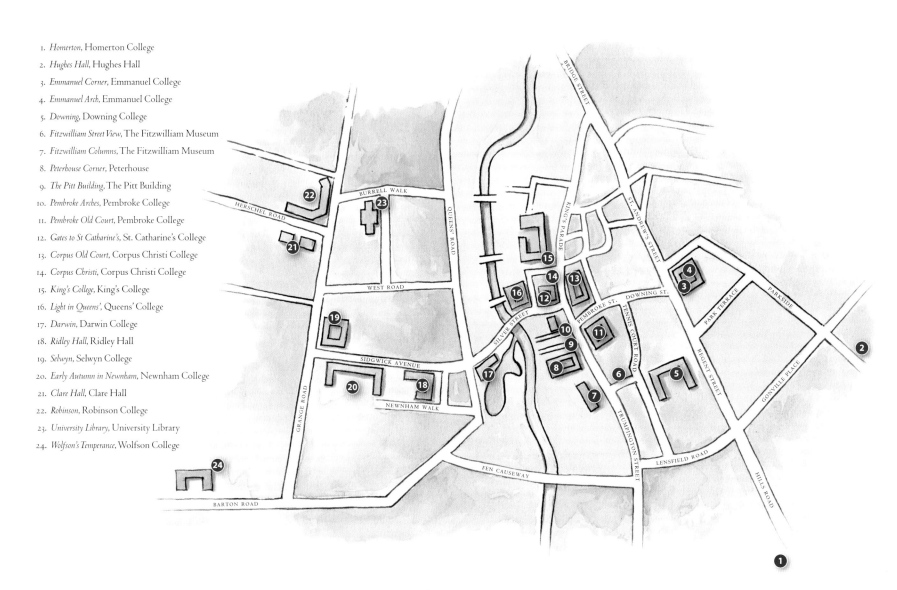

NORTHERLY APPROACH

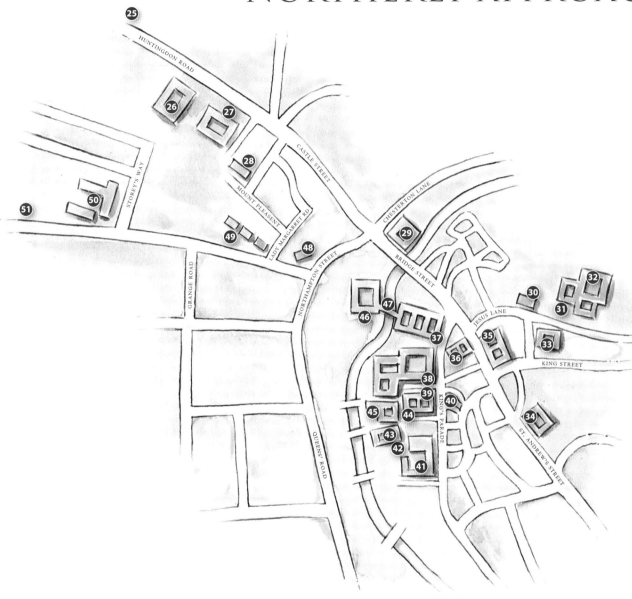

FOREWORD

Walking down Fitzwilliam Street the other day, between the terraced houses on either side, I looked up and saw, as it were for the first time, the southern pavilion of the museum's facade, with its tall Corinthian pilasters standing out in high relief against the smooth Portland stone. I have walked and cycled down that street on my way to work for years, but without attention, without a conscious appreciation of that particular 'frame' in the architecture of Cambridge. I realised, almost at once, that I was encountering one singular 'passage through time', which Ian Sheldon had traced in his 'Cambridge Footsteps'. It reminded me of what Elizabeth Bishop wrote to Robert Lowell in 1962; 'If, after I read a poem, the world looks like that poem for twenty-four hours or so, I am sure it is a good one – and the same goes for paintings.'

Ian admits readily that his attachment to Cambridge stems from the three years he spent here as an undergraduate. There is nothing unusual in that of course, or in the nostalgia with which so many of us look back to our 'salad days'. On the other hand, what he has produced is not simply an exercise in nostalgia, but a far richer visual narrative of the stones of Cambridge, including some of the more recent ones. In these there is an element of surprise; Robinson College looking like a twentieth-century San Gimignano, for instance. By others, where later interventions have created a veritable medley of styles, we are reminded that addition is a characteristic of Cambridge architecture, which has grown over the years to reflect the nature of our Collegiate University. Following Ian's gaze through one of the most picturesque corners of Tree Court in Gonville and Caius College, we are reminded by the caption that it was 'demolished and rebuilt, 1868–70.' Here, as T. S. Eliot famously pronounced, 'footfalls echo in the memory.' Much as we respect and value our architectural heritage, we have not allowed it, nor should we allow it, to constrain our development.

There is something about Ian's handling of watercolours that enables him to do far more than represent the buildings he chooses to paint; on page after page he captures the contrasts between sunlight and shadows, between weathered old surfaces and polished new ones, between the built environment and the landscape which is never far from it in Cambridge. His signature resides in his brushstroke, loaded with semi-transparent washes which capture the textures of brick and stone, concrete and glass. It is here that we, the viewers, encounter the artist's vision of things familiar to us, which we see again with his, and our own, fresh eyes.

Memory and emotion are fundamental to Ian's work. Whether he is painting the vast expanses of prairie in his native Canada, or narrowing his focus down to an individual specimen of its flora, he engages with his subject personally and intensely. In his deeply atmospheric watercolours of Cambridge he illustrates both his own 'passage through time' and the fact that, in the words of Adrian Stokes, 'geological time is out of scale with our own weathering.' In between these two lie eight centuries of human history of which our buildings are material evidence, worn as they are, most recently by our footsteps, on top of those more deeply imprinted by our illustrious predecessors.

To Ian and to Cambridge University Press we owe this vivid pictorial description of Cambridge past and present, both a souvenir of our time and an enduring visual record with which to mark our 800th Anniversary.

Duncan Robinson
MAGDALENE COLLEGE, CAMBRIDGE

NOTES FROM THE ARTIST

Narrow staircases twisting and turning, brick-faced courtyards and archways with hefty gates of weathered timber, candle-lit formal hall beneath ancient art and high ceilings – these were just some of the attractions of Magdalene College to me as an aspiring student. Perhaps deep down, even then, I knew that I was as fascinated by the architectural wonders of the University as the zoology that I was predestined to pursue.

In 1990 Magdalene embraced me into its fold, and three years were spent in a state of wild distraction befitting any student. The friendships, societies, supervisions, garden parties and balls in many colleges contributed to the love that I have for so many corners of so many courtyards in the city. Each college is unique and stands alone, but is made whole only by the greater presence of the University that casts its web over the city.

In my final year my passion for photography morphed into a love for painting. This love has never left me, and while I may have moved on to pastures foreign and new, so much of my heart remains sequestered underneath an arch of the Pepys Building or pausing for reflection upon Clare Bridge over a frozen, silent river.

The hustle and bustle of a busy city centre make it easy to overlook the opportunities for introspection. Few can afford the time to gaze silently through an archway and wonder at the great people who once strolled the corridors of academic excellence, better yet to ponder who might walk them in the future. Eight hundred years have passed and what great history will be made in the next?

The city has so many stories to tell, all cemented in the wood, stone, brick and concrete that hold the university on high. Buildings that seem ancient on the surface only just begin to tell the story of what lies beneath. Centuries of changing fashions cheat us of the truth; the brick façades of Peterhouse stood until masked by ashlar – a younger stony skin

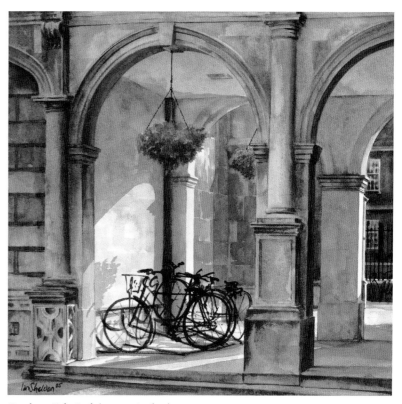

Peterhouse Bike Rack (10 × 10 inches)
Peterhouse. Looking through the arcade from Old Court into First Court, light silhouettes the bikes in the bike rack that is for Fellows only.

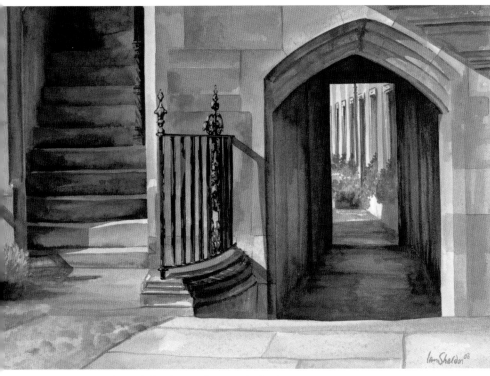

Caius College Passages (10 × 14 inches)
Gonville & Caius College. Looking through the northwest corner of Tree
Court, demolished and rebuilt in 1868–70, into Gonville Court.

over older bones, but even this skin dates back to the eighteenth century.
Just as old gets covered with new, tastes demand that tired plaster be stripped
away to reveal the ancient timbers of the medieval beneath.

Trees come and go as readily as the academics, but for those in the
city the arboreal souls have their place in history. Walking along the front
of Emmanuel recently, I gasped at the sudden absence of trees that once
fronted the college. Perhaps they outgrew their space, or maybe the college
wanted to reveal its pride in full glory. Now those trees have gone. New
students will never know they were there, old students will reflect on what
once was, and the ghosts of students long gone may well rejoice in the return
of what they used to know.

I've watched as the dirty industrial history has been sand-blasted
off the face of the Senate House, wiping away years of grime along with its
attendant stories. The artist in me decries the cleaning of buildings to reveal
the crisp clean stone beneath; no more cascades of dirty tears dripping from
the corners of windowsills and no more splattered stains revealing leaky
gutters – a deprivation for my brushes.

But this is what time does to an ancient city; it yields to the whims
and wishes of man, and the city evolves as the giant organism that it is.
Thankfully the days are long gone when the old might have been levelled in
favour of the new. With an awareness of the value in architectural history,
renovation is the order of the day. When expansion is required, architectural
marvels are revealed, stylish buildings merge one century with another. The
character of the city is maintained, but allowed to advance into the future.

The city and the University are at once grand and intimate, old
and new, static and transient. I've been in awe of its grandeur, and cherished
its subtlety. I've revered the ancient and admired the modern. I've been
grounded by the static and unseated by the ephemeral. All of these facets
have given me creative inspiration. In this volume of watercolours that I have
tried to capture some of the emotions and feel of Cambridge, having seen
possibly every corner there is to see. I haven't resisted the grand and
predictable like King's College Chapel, but I've also presented the small

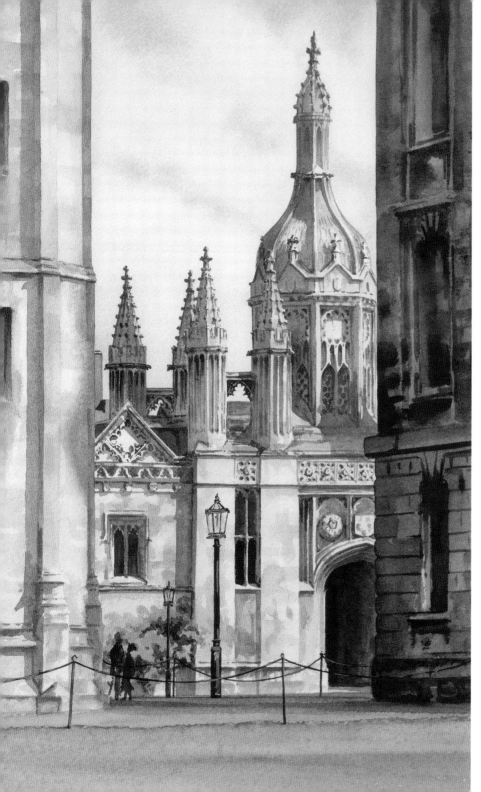

and overlooked – a deliberate act to expose the rich beauty and temporal diversity of Cambridge. I've played in the shadowy colours of the cloisters of Queens' and exposed a surprising view over a wall into New Hall. I have collected the paintings into two walks, with a southerly or northerly approach, mingling old with new, and revealed a few treasures like the Cambridge Observatory.

 As the University of Cambridge proudly marches on into its ninth century, who knows what is yet to come, but somewhere in the shadows of the corridors and courtyards, I hope to march on too.

Ian Sheldon

King's College View (14 × 10 inches)
King's College. From near the river, a glimpse of the Gothic Revival gatehouse (1824–28) is afforded between the Chapel and the Gibbs' building.

THE PAINTINGS

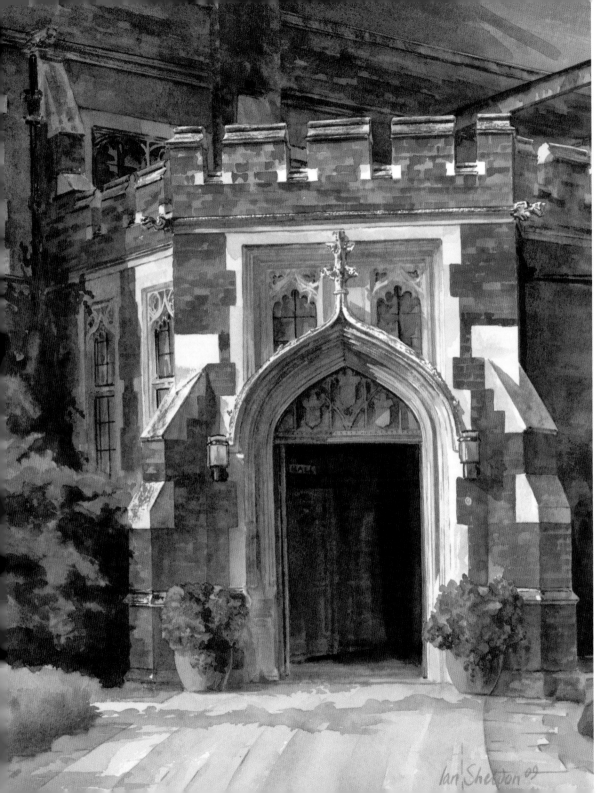

Ian Shelton 09

<

1. *Homerton* (12 × 9 inches)
Homerton College.
The entrance to the Great Hall in
the original buildings of the College
(1876–89) by Giles & Gough.

>

2. *Hughes Hall* (14 × 10 inches)
Hughes Hall.
The main door to the original
building of the College (1894–95)
by W. M. Fawcett.

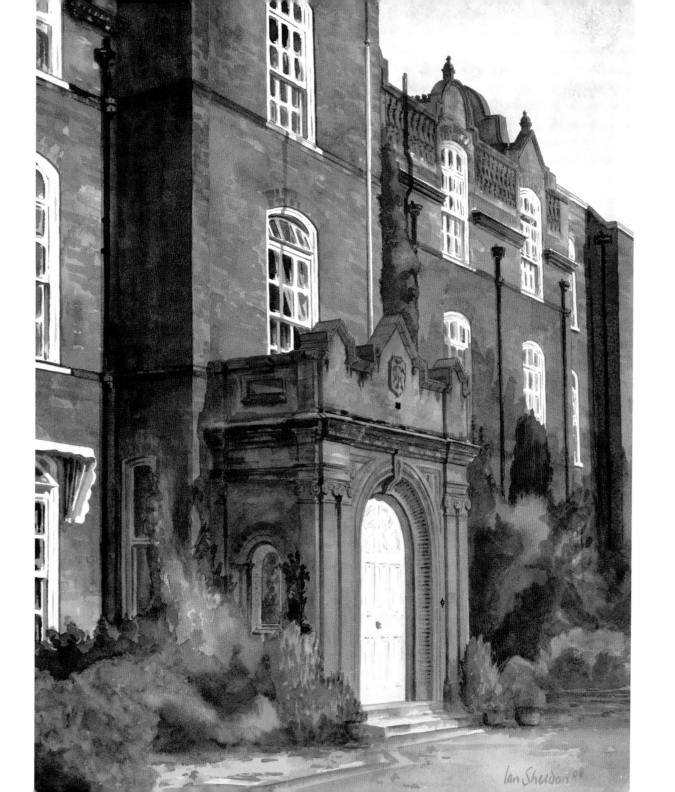

Ian Sheldon '98

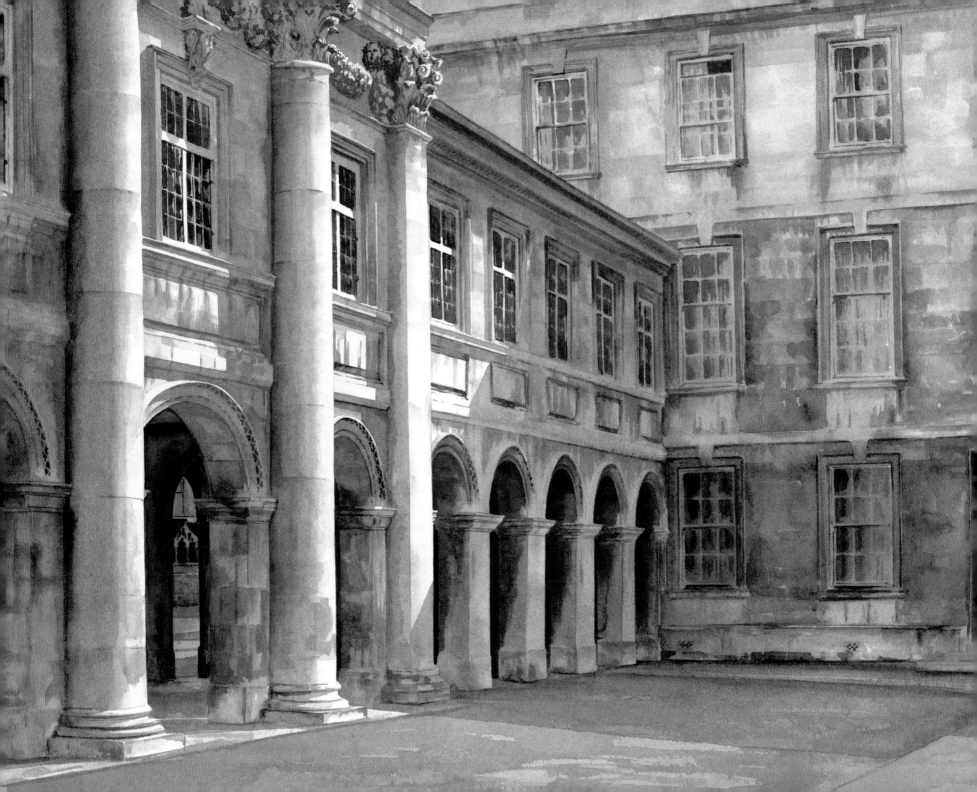

<

3. *Emmanuel Corner* (15 × 20 inches)
Emmanuel College.
The corner of Front Court
reveals some of the detail of
the chapel (rebuilt in 1668–74
by Christopher Wren) and the
Westmoreland Building along the
south range (1719–22).

>

4. *Emmanuel Arch* (12 × 5 inches)
Emmanuel College.
A view from the cloisters
of Front Court to the
Westmoreland Building.

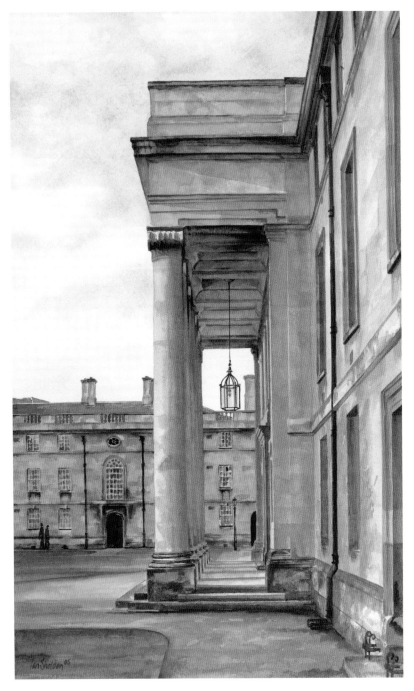

< >

5. *Downing* (17½ × 10½ inches)
Downing College.
Looking through the Chapel's
portico (1951–53) at Sir H. Baker's
Graystone Buildings (1929–32).

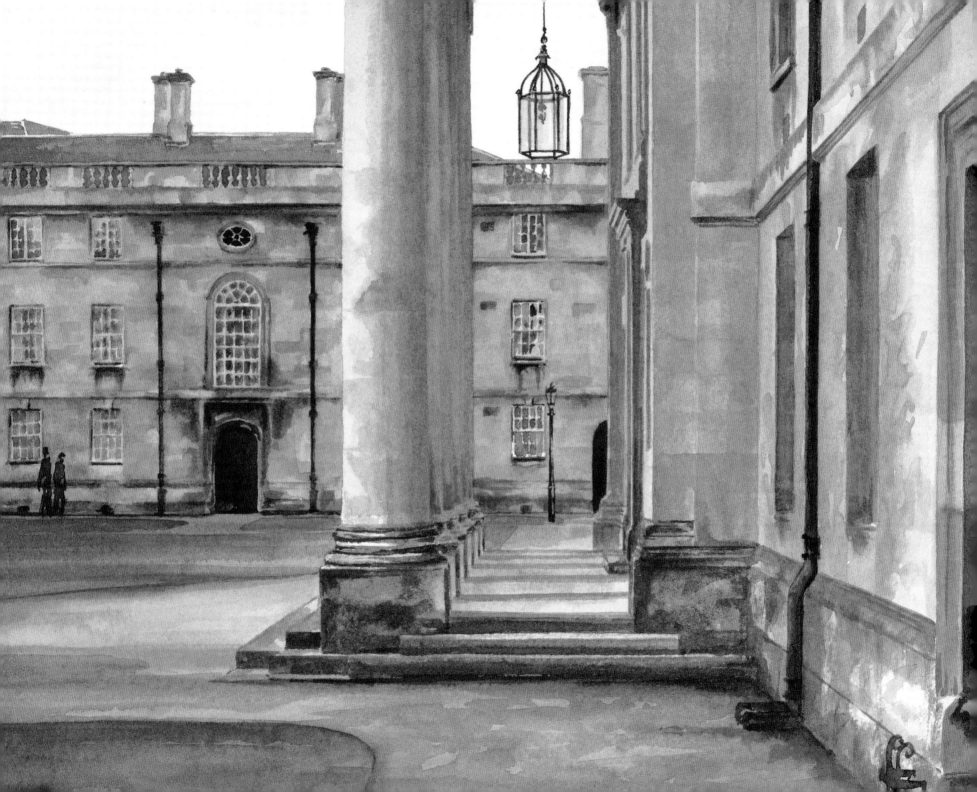

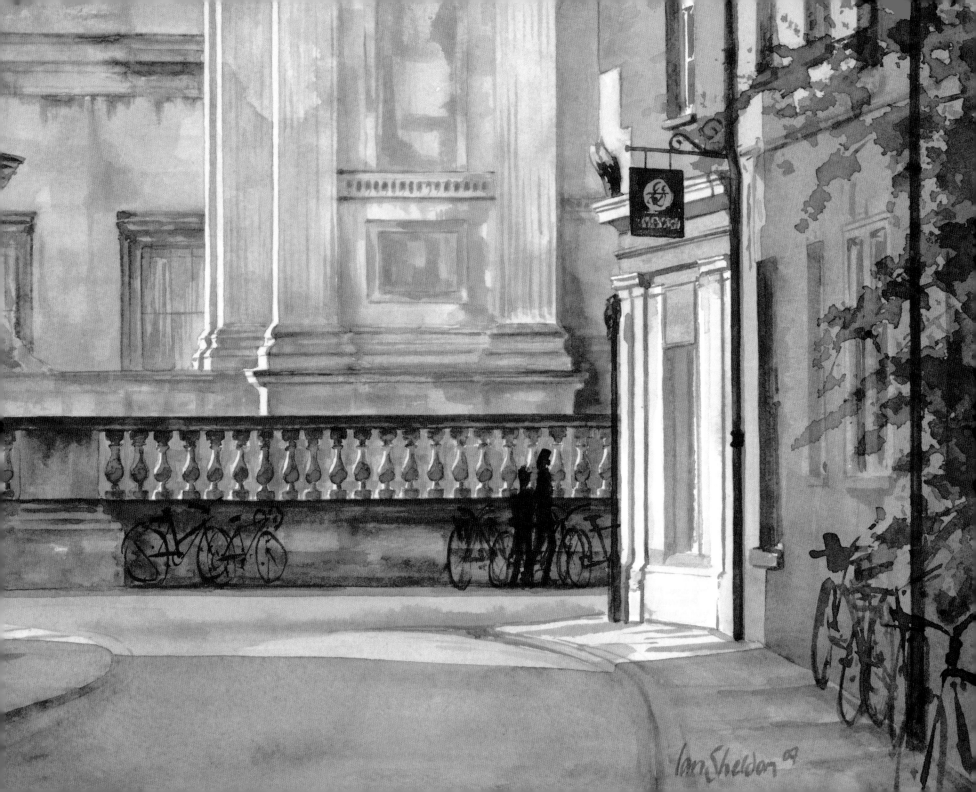

< >

6. *Fitzwilliam Street View*
(20 × 17 inches)
The Fitzwilliam Museum.
A detail of the main entrance to the
museum is revealed from Fitzwilliam
Street, lined with its early 19th
century houses.

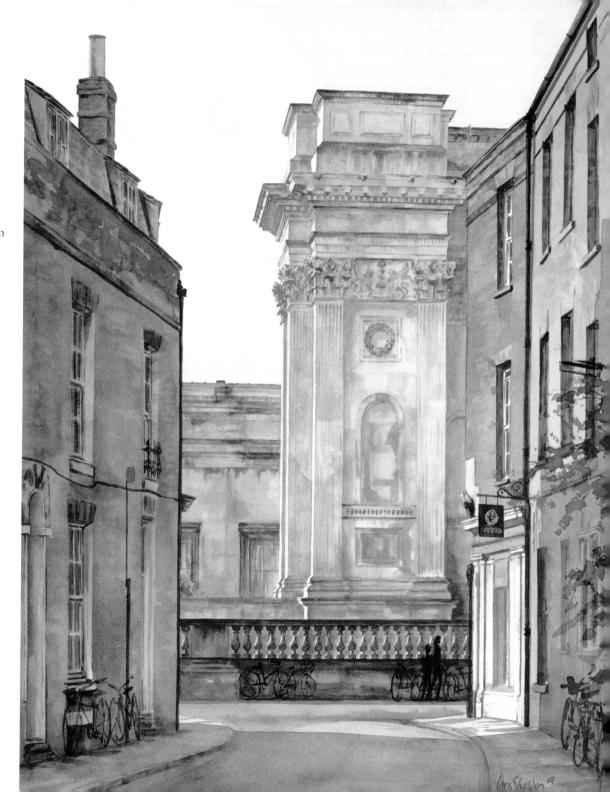

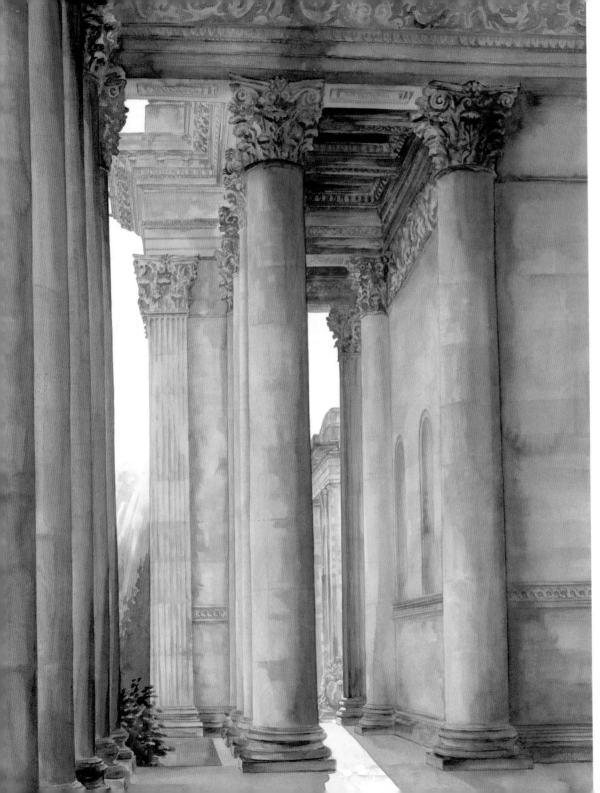

<

7. *Fitzwilliam Columns*
(27½ × 20½ inches)
The Fitzwilliam Museum.
Light floods through the grand
columns of the Victorian Baroque
entrance to George Basevi's
Fitzwilliam Museum (1837–41).

>
8. *Peterhouse Corner* (28 × 15 inches)
Peterhouse.
Sunlight streams under the arcades
(rebuilt 1709–11) that join the
17th century Chapel to the north
face of Old Court, originally
15th century brick buildings that
were ashlared in 1754.

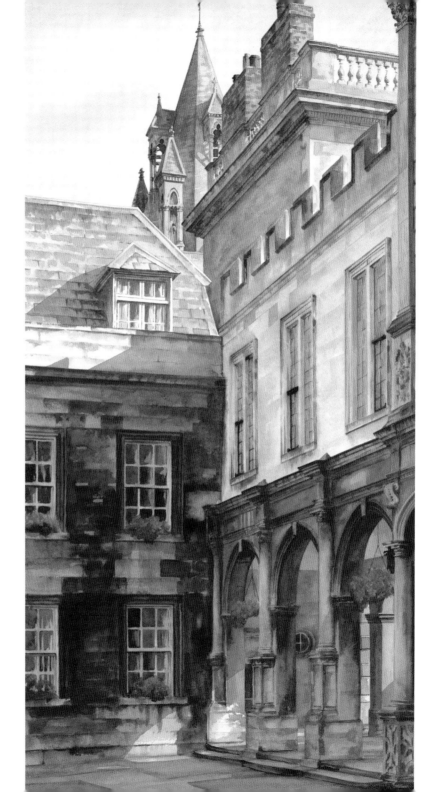

\>

9. *The Pitt Building* (20 × 24 inches)
The Pitt Building.
The tower of Cambridge University
Press's Pitt Building (1831–33)
dominates Trumpington Street;
it was named after British Prime
Minister William Pitt the Younger
(1759–1806).

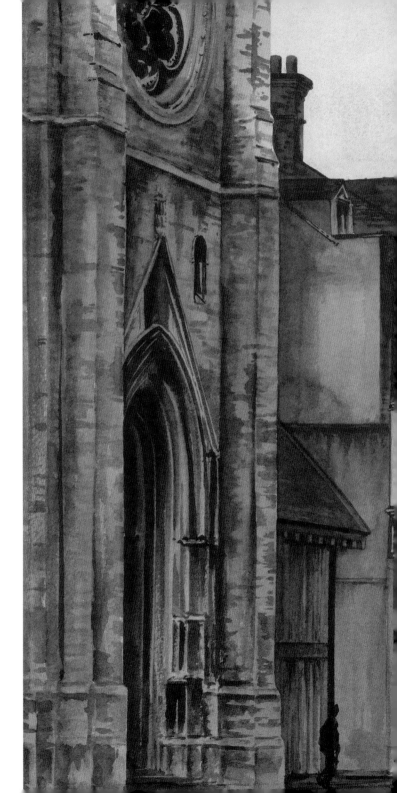

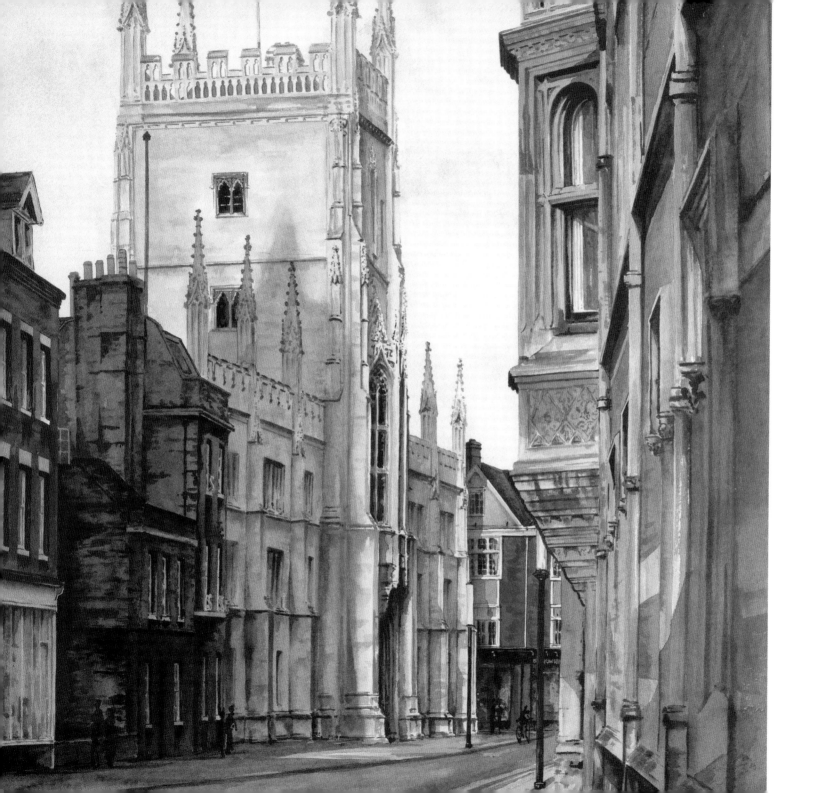

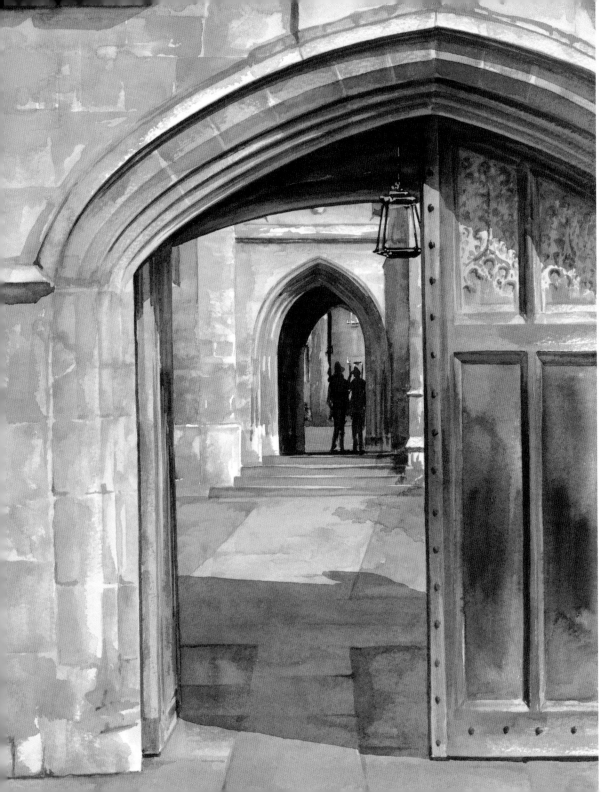

<
10. *Pembroke Arches* (15 × 10 inches)
Pembroke College.
From Trumpington Street, heavy
wood doors guard the 14th century
Main Gate into Old Court, all of
which was ashlared in 1712 and 1717.

>
11. *Pembroke Old Court*
(16 × 22½ inches)
Pembroke College.
Old Court is dominated by a
walnut tree donated to the College
in 1982, a recent addition to
the courtyard that dates from
14th century, with additions in the
17th and 19th centuries.

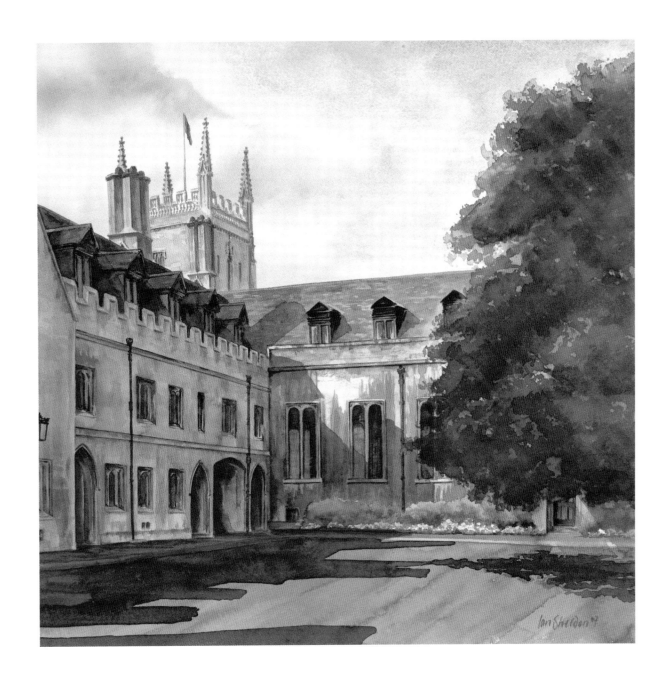

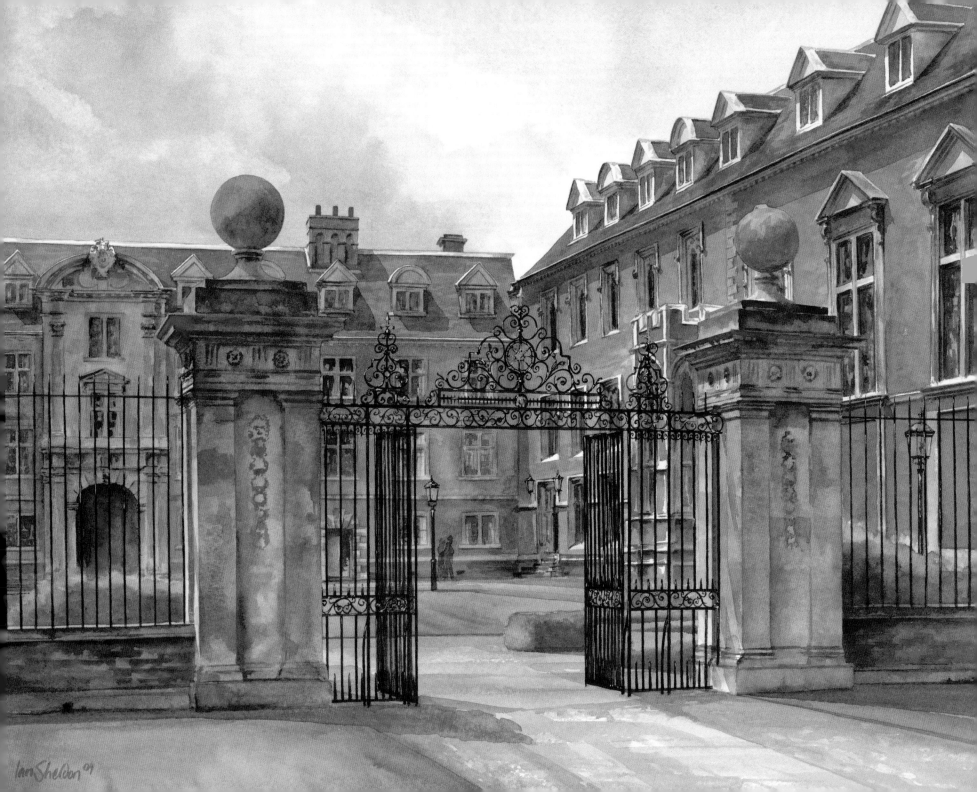

<

12. *Gates to St Catharine's*
(14 × 21 inches)
St. Catharine's College.
Wrought iron gates are seldom open
to Trumpington Street except during
graduation ceremonies; the buildings
of Main Court behind the gates date
from 1673–1704.

>

13. *Corpus Old Court* (18 × 11 inches)
Corpus Christi College.
Windows and doorways define this
corner of Old Court, completed
in 1377, with the buttresses added
between 1487 and 1515.

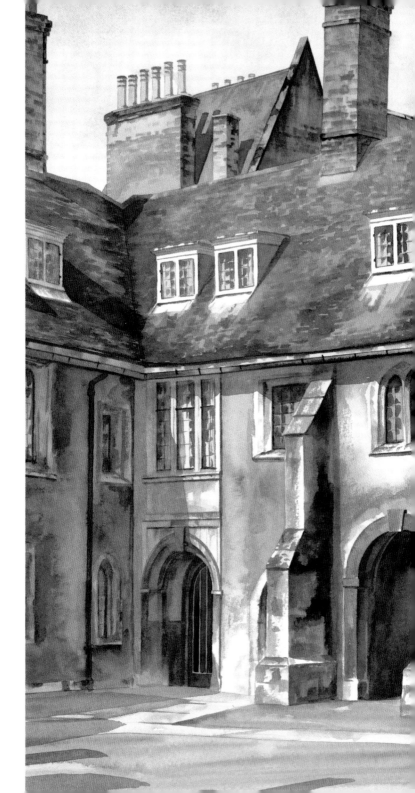

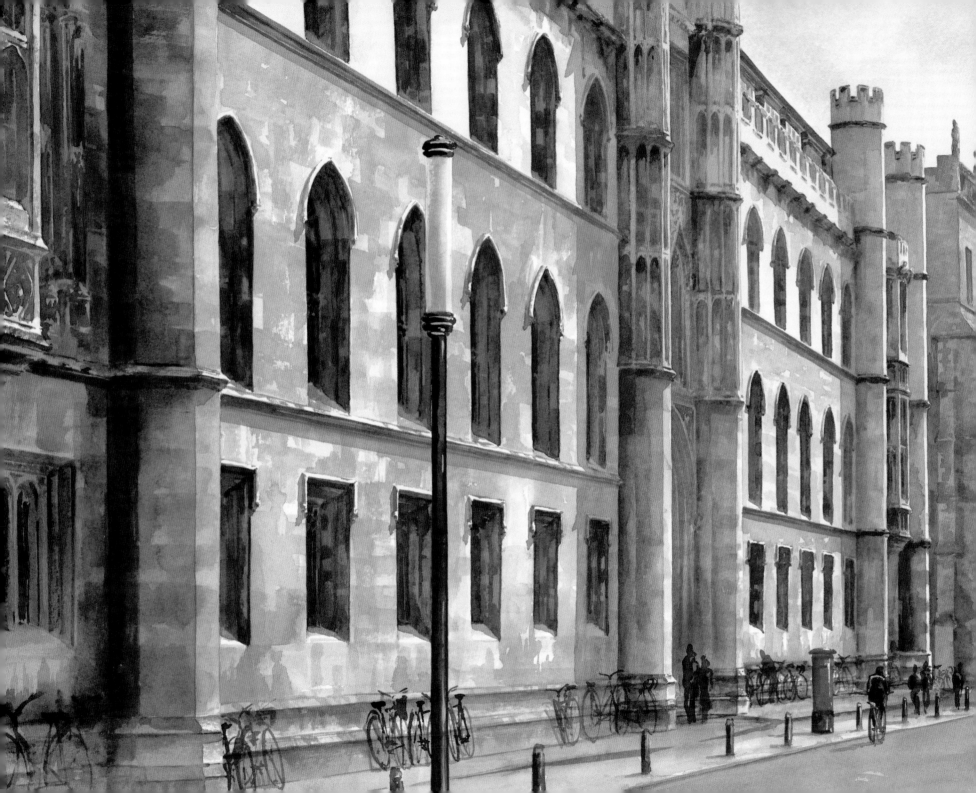

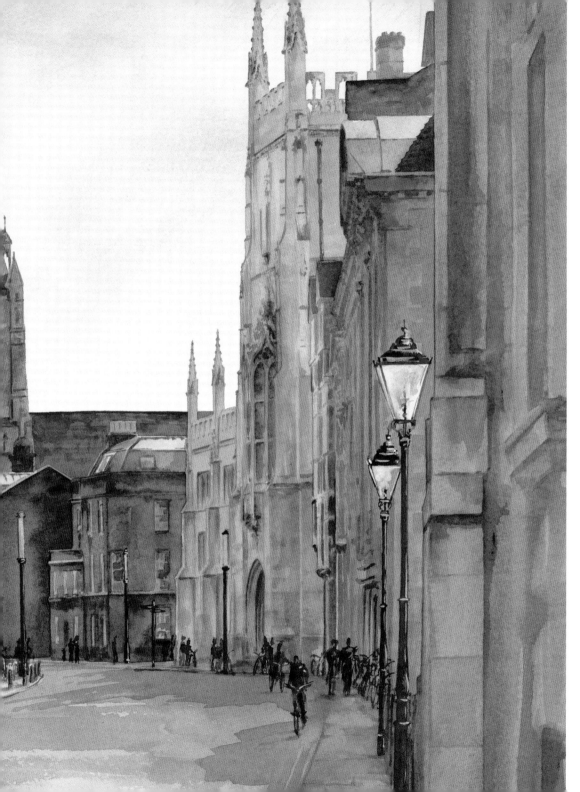

14. *Corpus Christi* (20 × 28 inches)
Corpus Christi College.
The Gothic Revival façade of
New Court, built in 1823–27 by
William Wilkins, pulls the eye down
Trumpington Street to the tower of
the Pitt Building across the street.

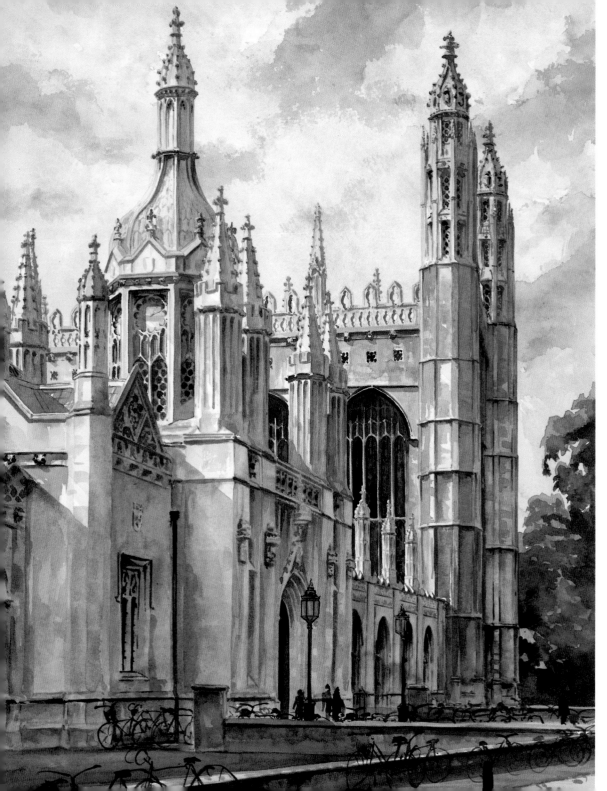

< >

15. *King's College* (20 × 15 inches)
King's College.
As Trumpington Street becomes
King's Parade at Bene't Street, the
Gothic Revival screen and gatehouse
(1824–28) dominates the scene.

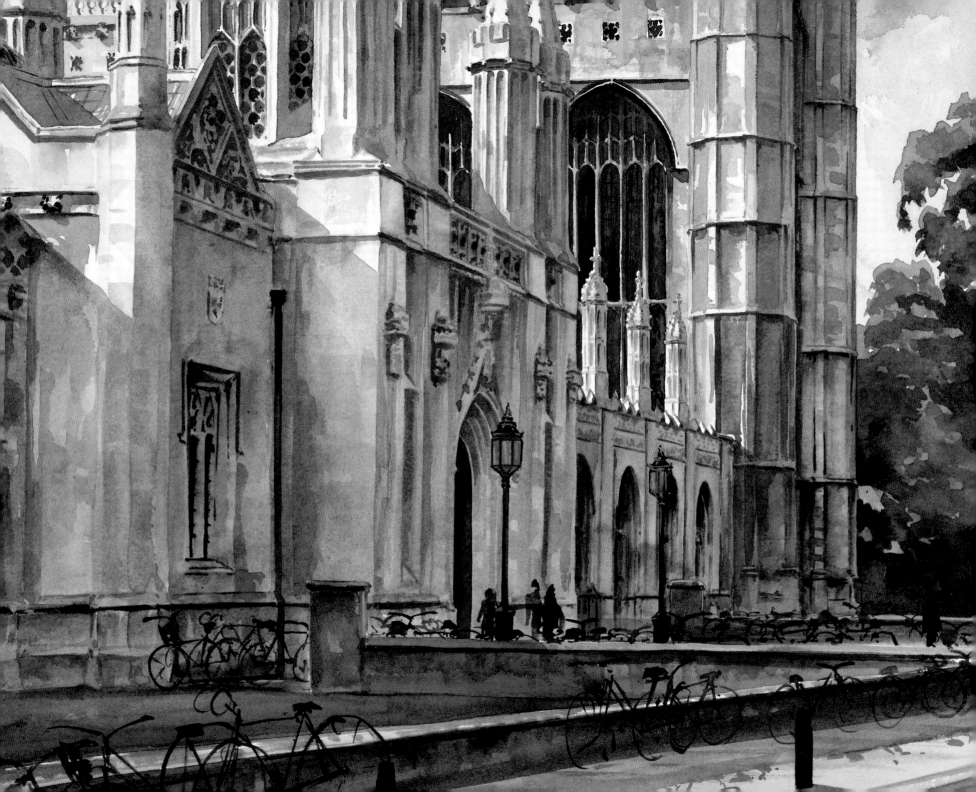

> 16. *Light in Queens'* (16 × 13 inches)
Queens' College.
Sunlight floods into the cloisters
underneath the heavily timbered
President's Gallery from the mid
16th century.

>> 17. *Darwin* (12 × 16 inches)
Darwin College.
The Old Granary is a well-known
landmark from the river Cam and
The Anchor pub, and became part
of the College when it was founded
in 1965.

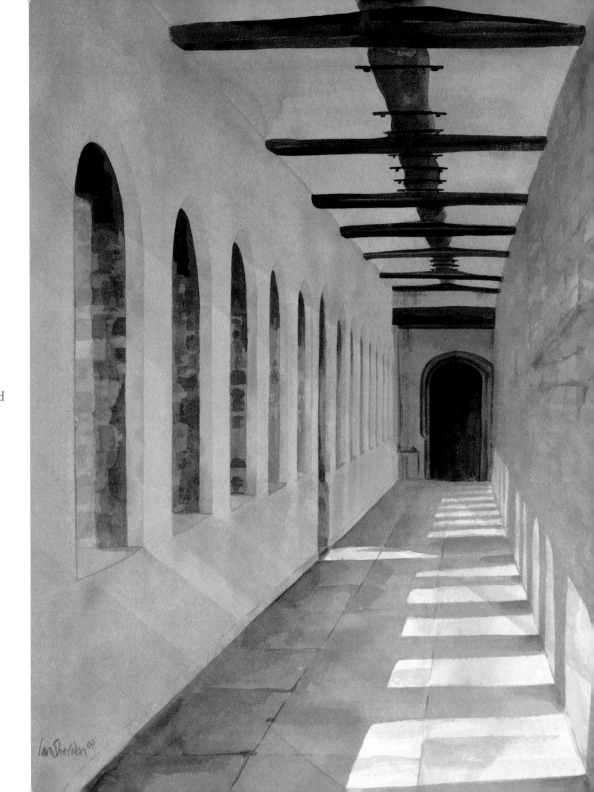

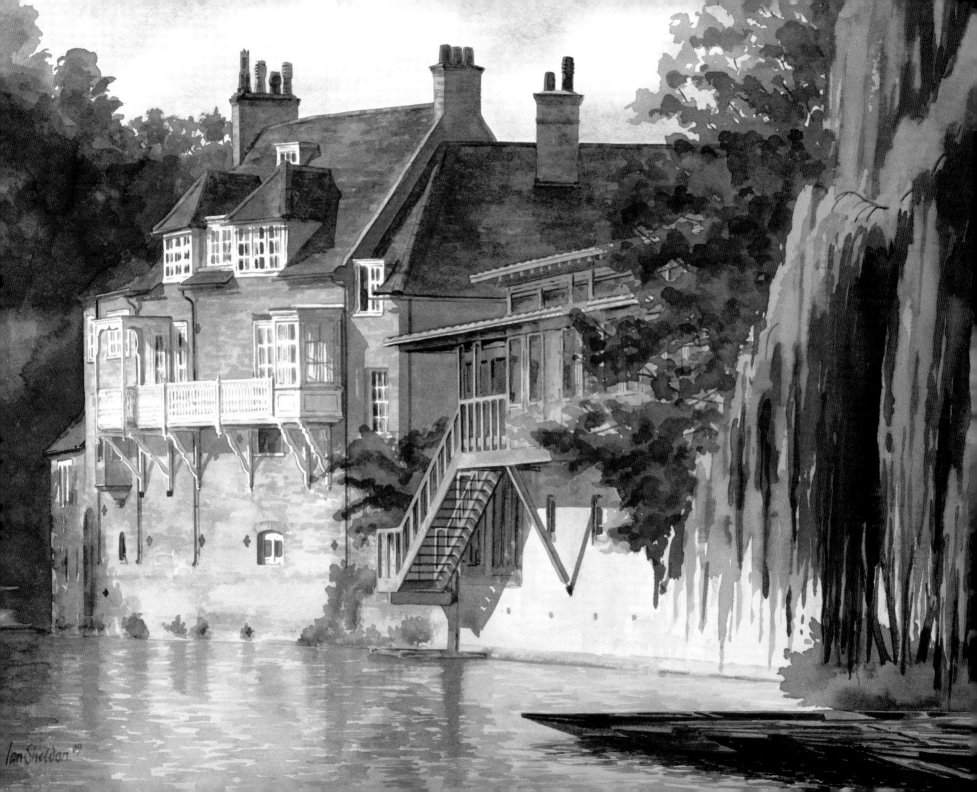

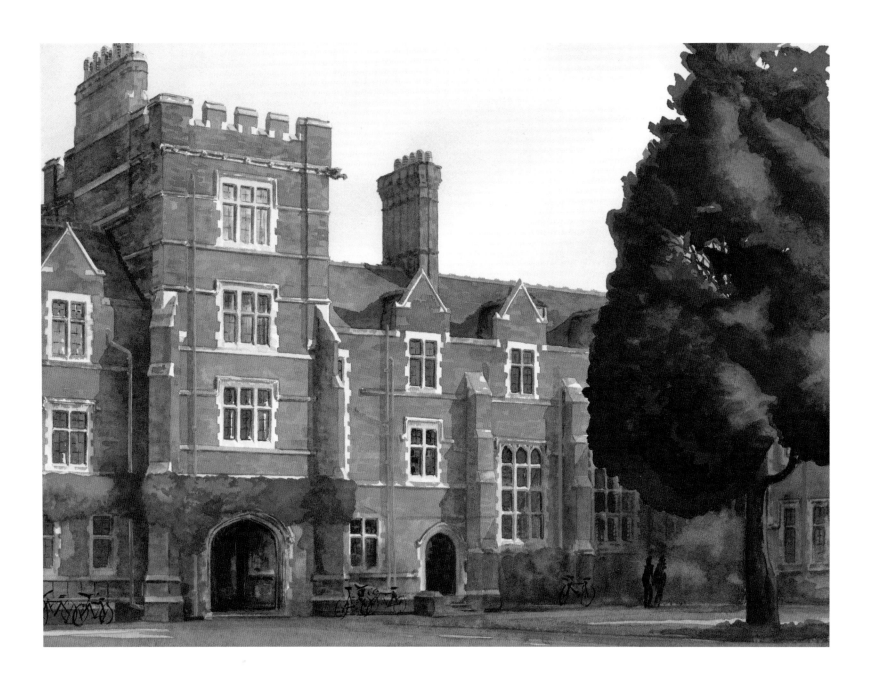

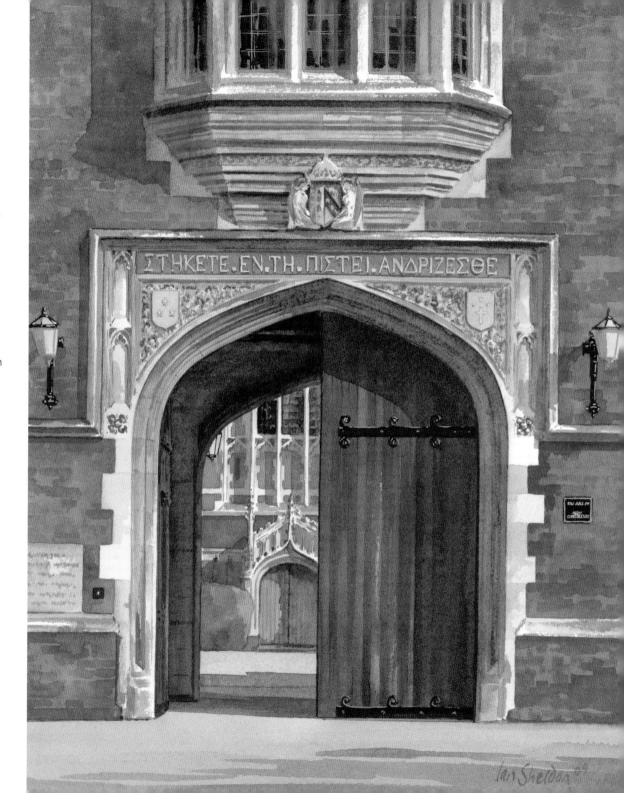

<

18. *Ridley Hall* (10 × 12 inches)
Ridley Hall.
The east range and main gate, built
by Charles Luck in 1879–81, as seen
from inside the College grounds.

>

19. *Selwyn* (11 × 9 inches)
Selwyn College.
A view into Selwyn from Grange
Road, looking through Sir Arthur
Blomfield's West range of 1882 with
the chapel door in the distance.

> 20. *Early Autumn in Newnham*
(16½ × 23½ inches)
Newnham College.
Virginia creeper turns red on
Basil Champneys' Sidgwick Hall
(1880) with Clough Hall (1888) set
further back in the treed grounds of
the College.

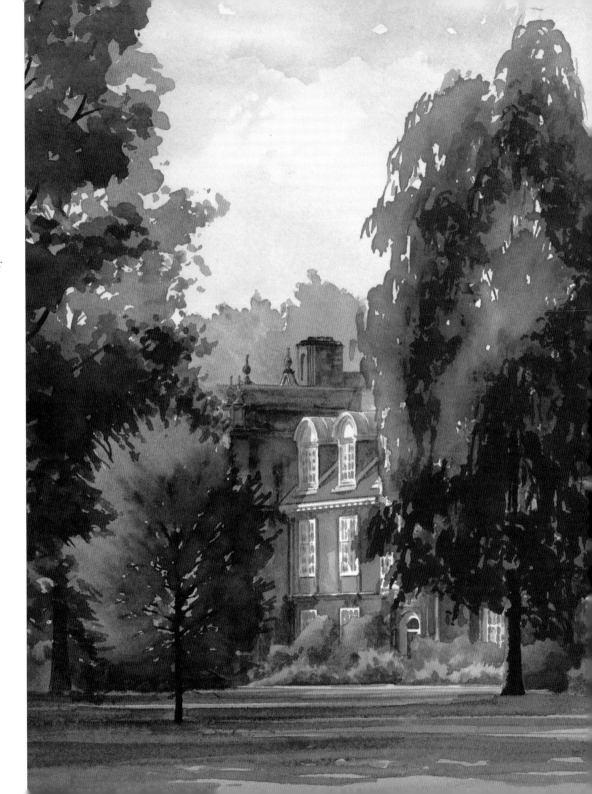

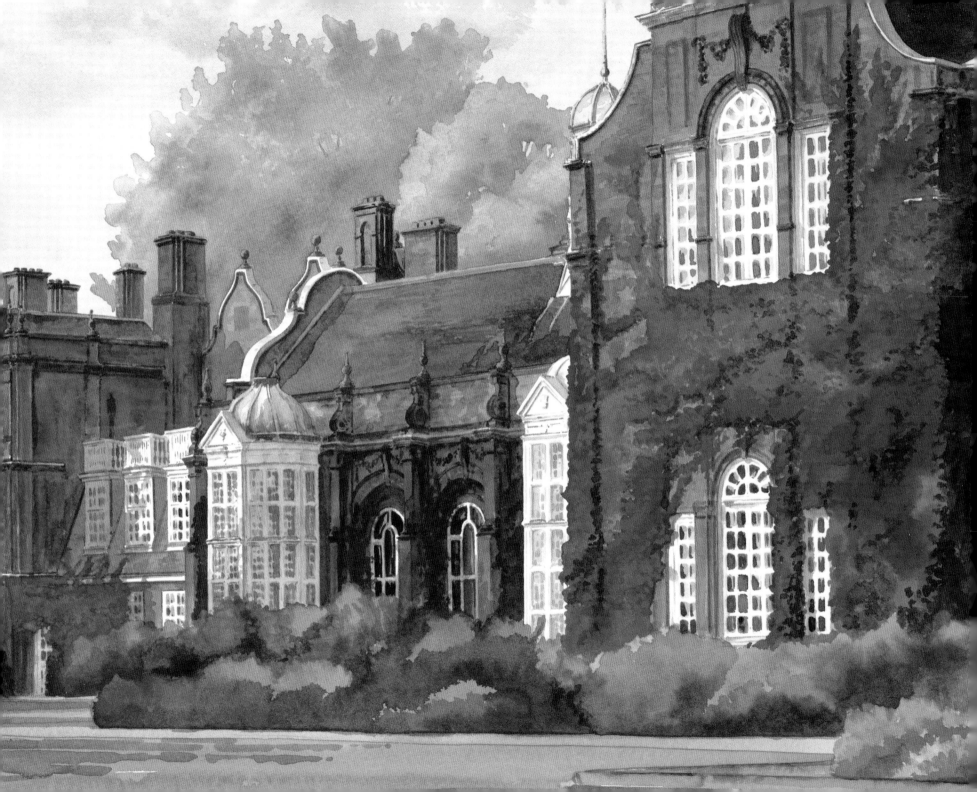

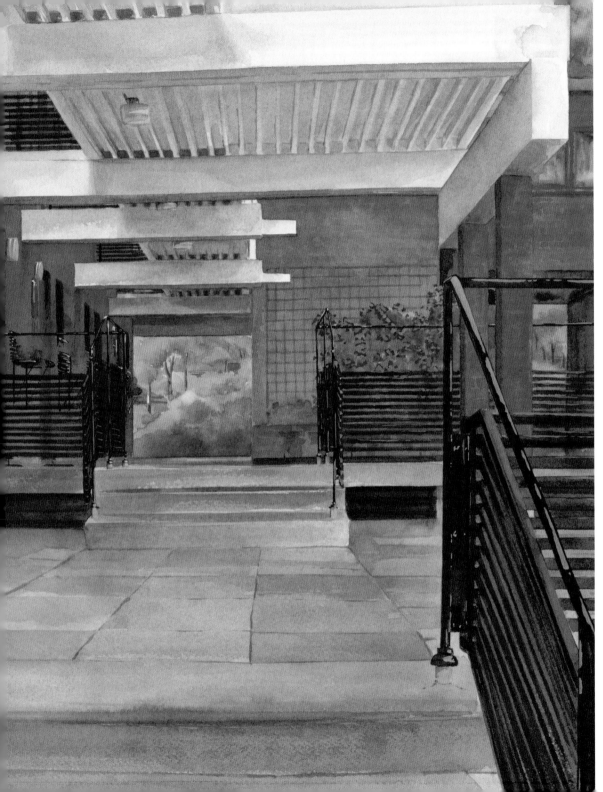

<
21. *Clare Hall* (14 × 14 inches)
Clare Hall.
Linear elements characterise the late
60s additions to Clare Hall, as seen
in this view inside the West Strip,
designed by Ralph Erskine after the
College's founding in 1965.

>
22. *Robinson* (20 × 20 inches)
Robinson College.
The inside of Long Court, with the
chapel window visible at the end,
is a bold statement in brick;
the youngest College, this building
was completed in 1980.

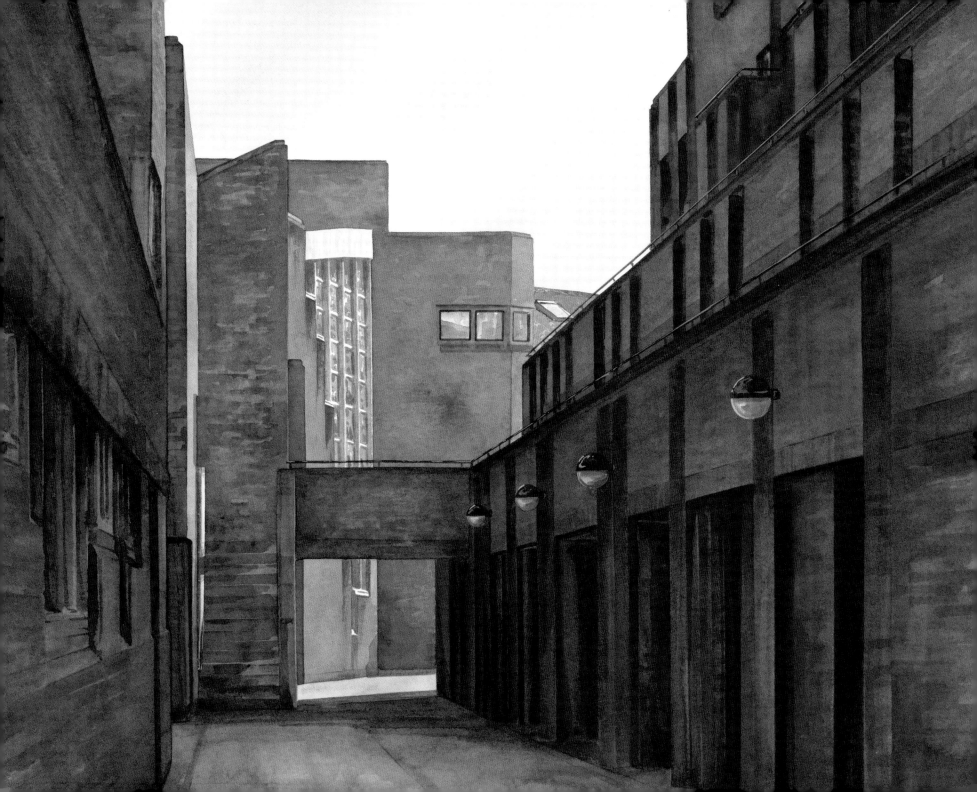

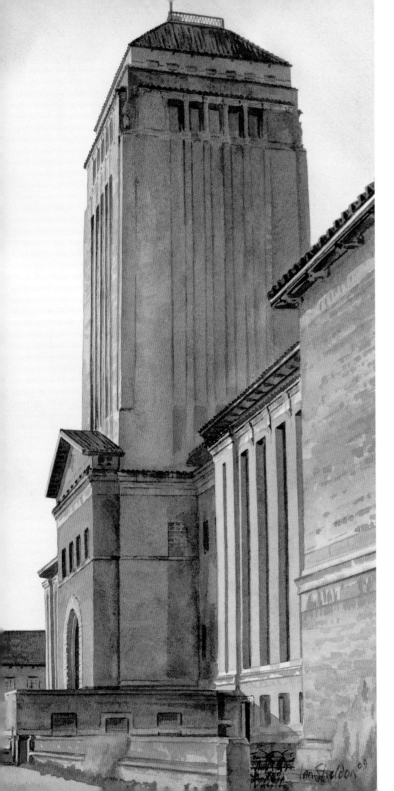

<
23. *University Library* (12 × 6 inches)
University Library.
Sir Giles Gilbert Scott's early
1930s creation for the new library
dominates the city's skyline, as
shown from the north end of the
extensive building.

>
24. *Wolfson's Temperance* (9 × 10 inches)
Wolfson College.
Lady Temperance Fountain adds
tranquility to the fusion of old
and new buildings for this College,
founded in 1965.

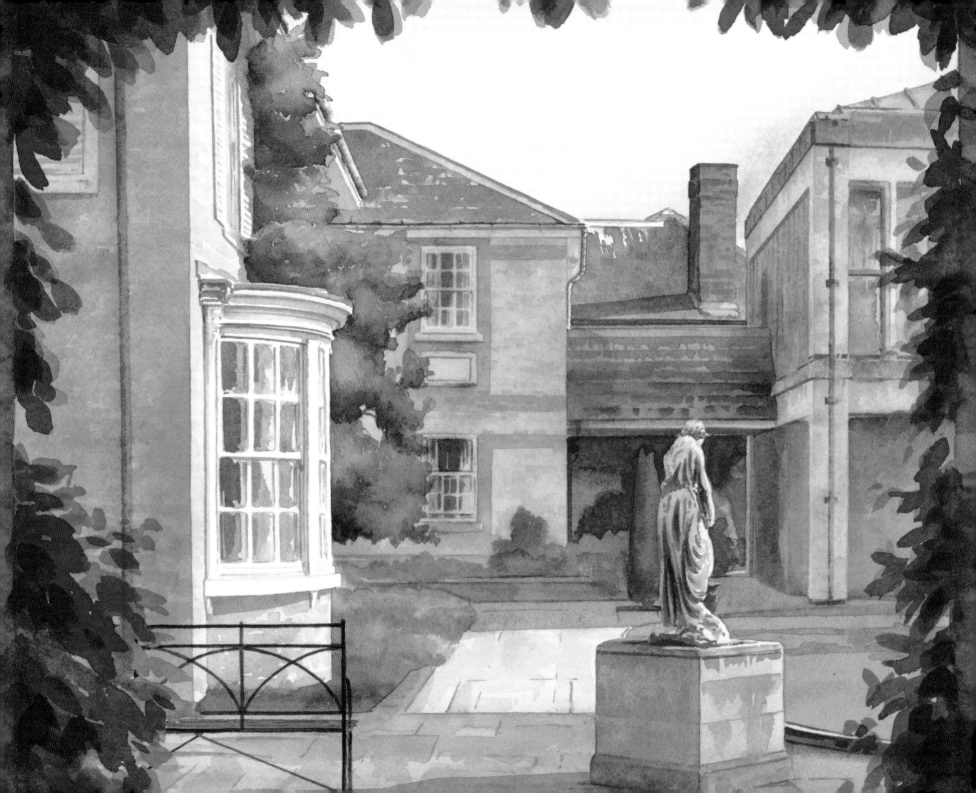

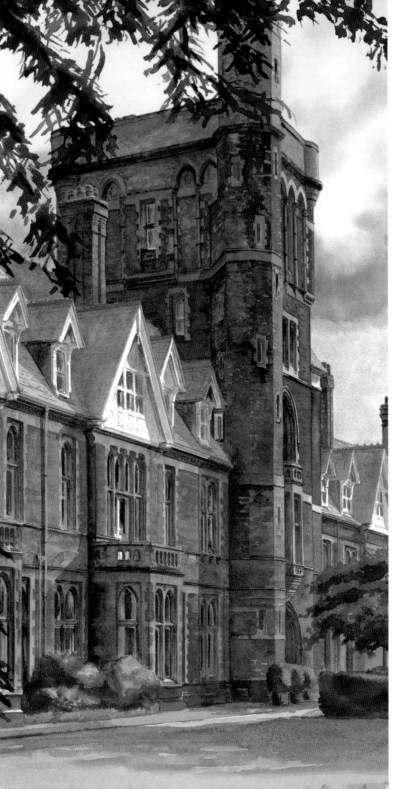

<

25. *Girton's Gatehouse* (18 × 11 inches)
Girton College.
Tower Wing's gatehouse, built by
Paul Waterhouse in 1887, can be seen
from under the trees fronting
Emily Davies Court.

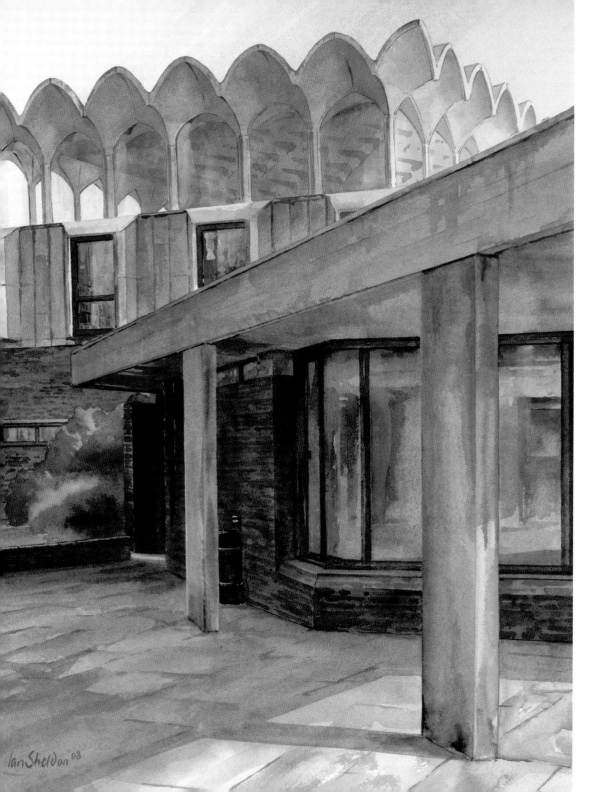

<

26. *Fitzwilliam's Hall* (16 × 12 inches)
Fitzwilliam College.
Sir Denys Lasdun's early 1960s
canopy of the Hall dominates the
centre of the College.

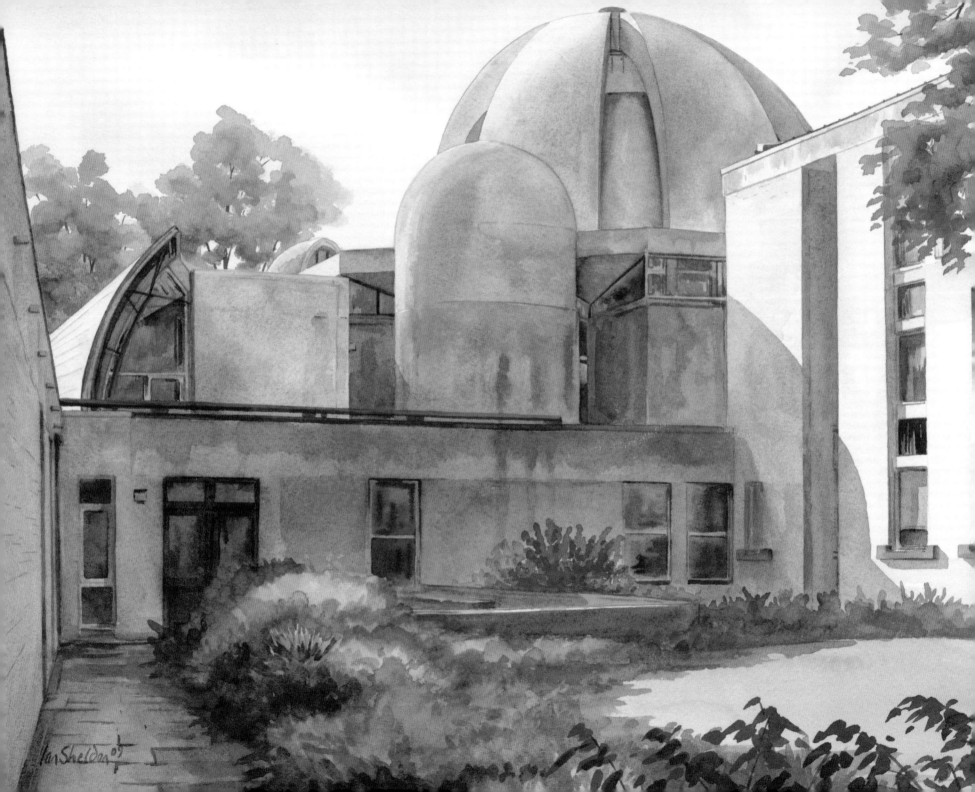

<

27. *Shapes of Murray Edwards*
(10 × 14 inches)
Murray Edwards College (New Hall).
A surprising view over a wall from
Huntingdon Road provided this
seldom-seen view of some of the shapes
of the College, built in 1962–66.

>

28. *St. Edmund's* (8½ × 11 inches)
St. Edmund's College.
A 1993 addition to the Ayerst Building
of the late 19th century frames the doors
to the reception of the College.

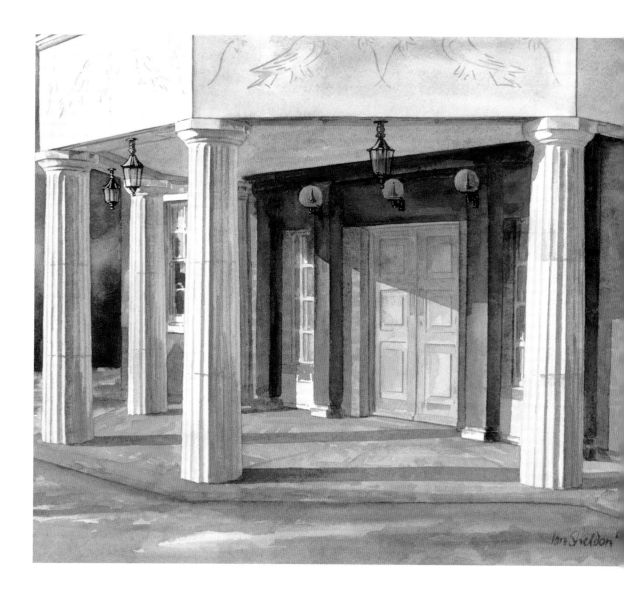

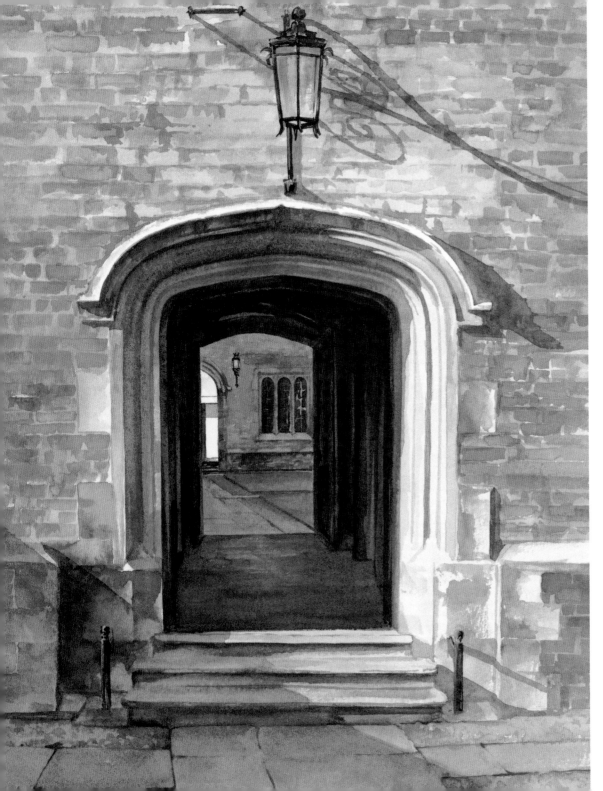

<
29. *Magdalene* (12 × 9 inches)
Magdalene College.
Seen from Second Court,
Screens Passage Gateway leads
past the College's Hall of 1519 into
First Court.

>
30. *Wesley House* (9 × 11 inches)
Wesley House.
Shadows cast their length across the
east face of the courtyard, much
of which was built by Maurice Webb
in the late 1920s.

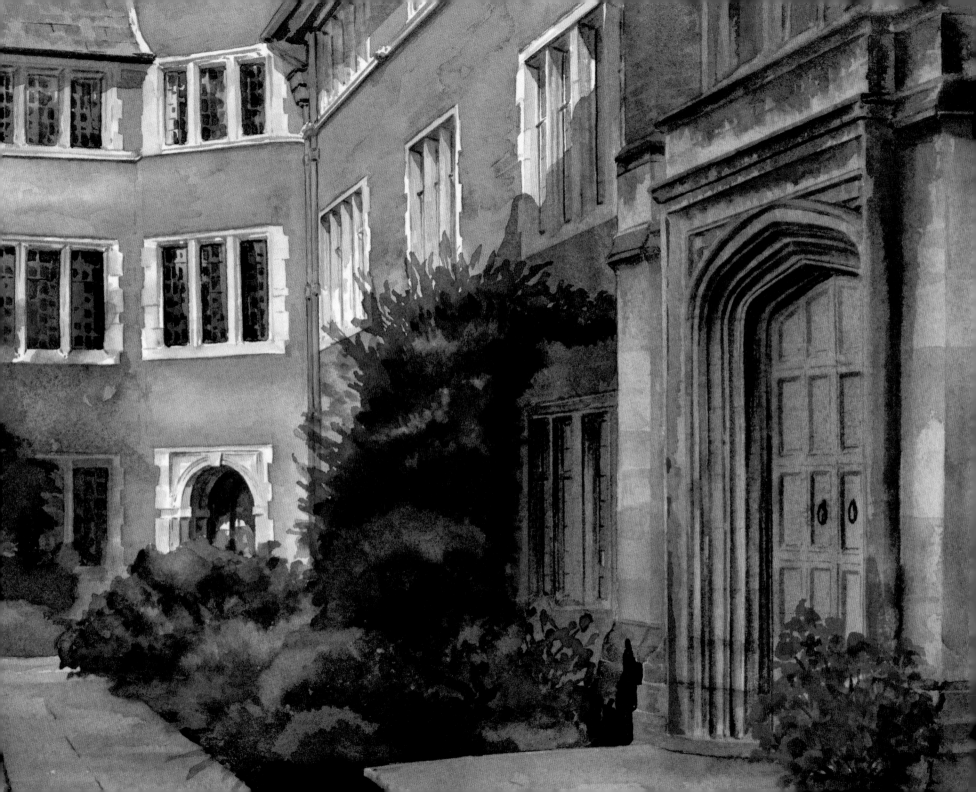

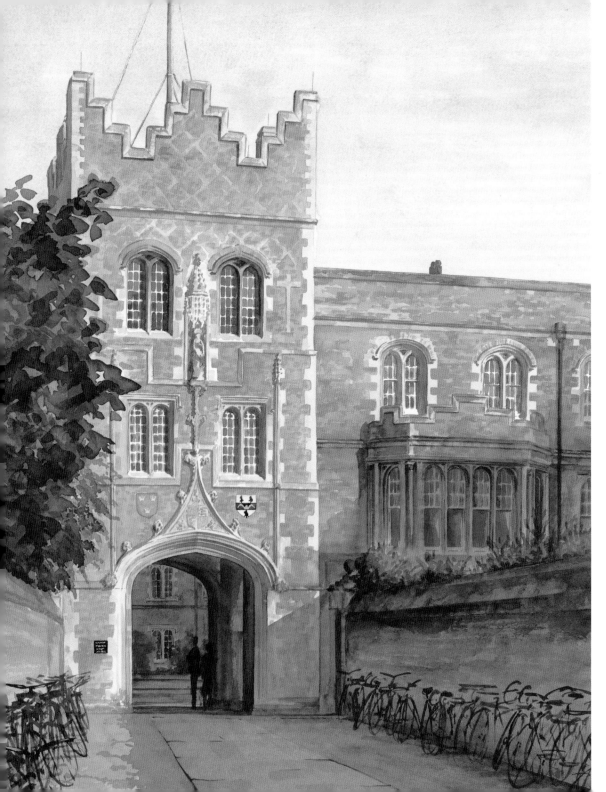

<

31. *Jesus* (20 × 24 inches)
Jesus College.
From Jesus Lane, bikes line the
Chimney, the so-called passage that
leads to the early 16th century Tudor
gatehouse, with the Master's Lodge
to the right.

>

32. *Cloisters in Jesus* (10 × 10 inches)
Jesus College.
Sunlight spills through the 18th
century cloisters of Cloister Court,
parts of which are thought to date
back to the mid 12th century.

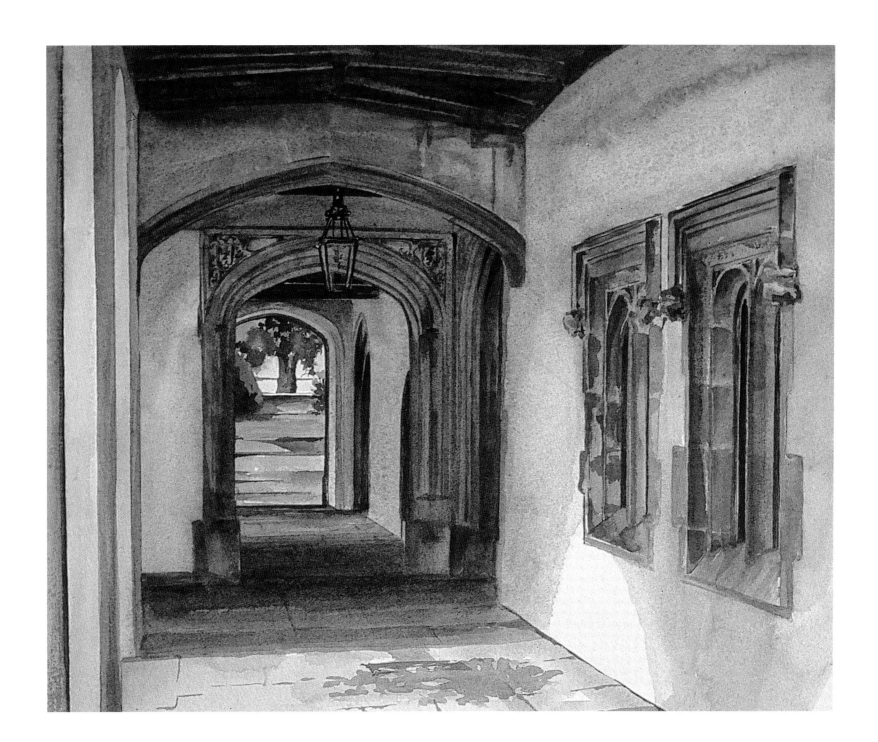

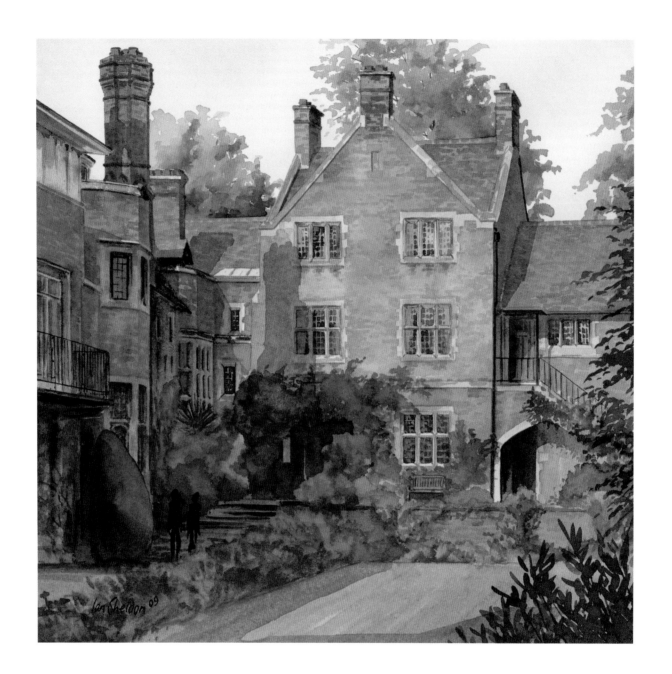

<

33. *Westcott House* (10 × 10 inches)
Westcott House.
Inside the small courtyard, the 1899 north face (by Grayson and Ould) represents the original part of the College.

>

34. *Christ's Windows* (14 × 12 inches)
Christ's College.
An oblique look down St. Andrew's Street along this 16th century façade reveals Robert Grumbold's ashlar, fashionably added in 1714–16.

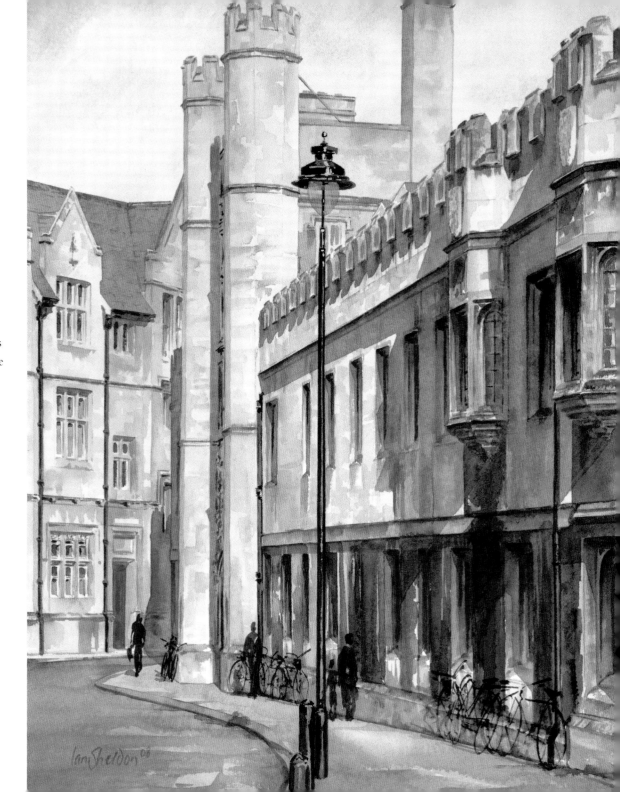

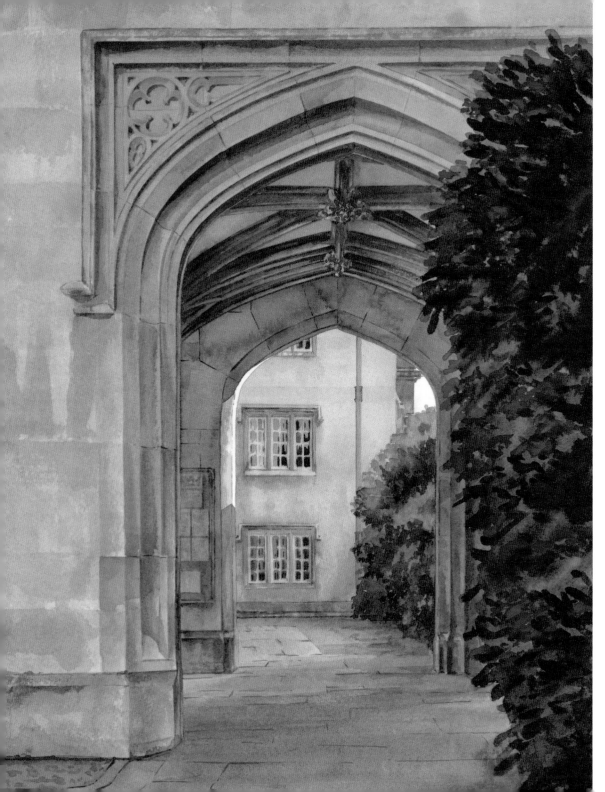

<
35. *Sidney Sussex Glow* (14 × 10 inches)
Sidney Sussex College.
Looking from Hall Court into
Chapel Court past the Porter's
Lodge, a 19th century alteration
concealing the 16th century origins
of the buildings.

> 36. *Whewell's Court Arches*
(10 × 7¾ inches)
Trinity College.
A tunnel-like view from the first of
the Whewell's Courts through the
arches into the second, the courts
being an extensive mid 19th century
addition to the College, across
Trinity Street.

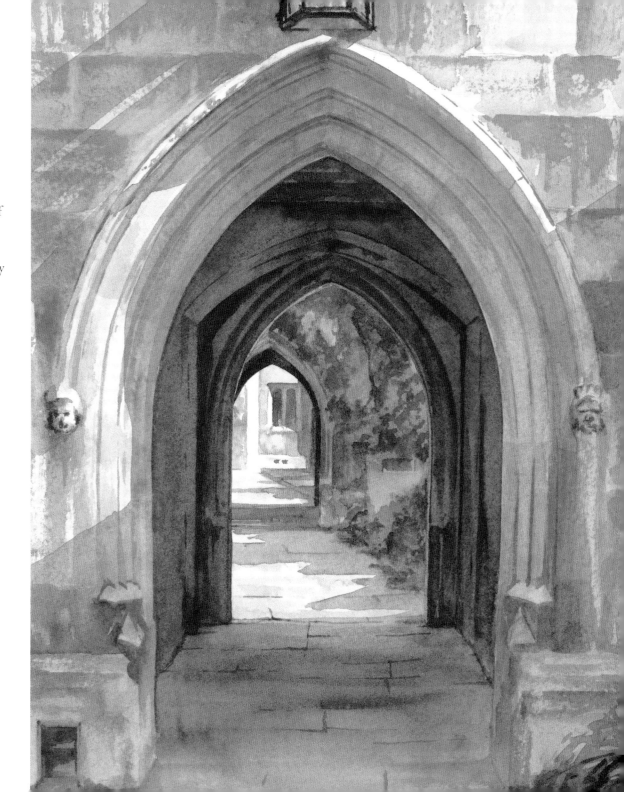

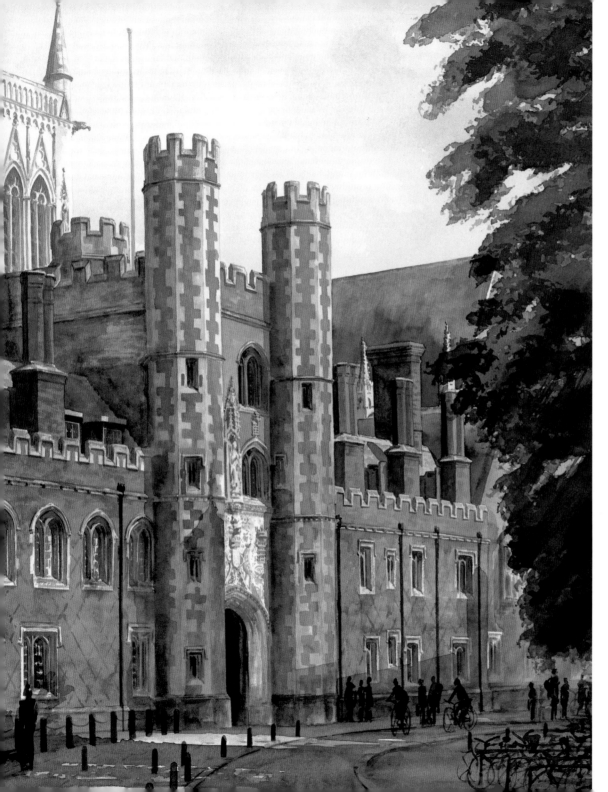

<

37. *Gatehouse to St. John's* (20 × 20 inches)
St. John's College.
The gatehouse of 1511 as seen from
Trinity Chapel, looking along
St. John's Street.

>

38. *Trinity Lane* (17½ × 12 inches)
Trinity Lane.
A quiet diversion from the bustle of
Trinity Street, this lane separates
Gonville & Caius on the left, and the
exterior of the 17th century south face
of Trinity's Great Court.

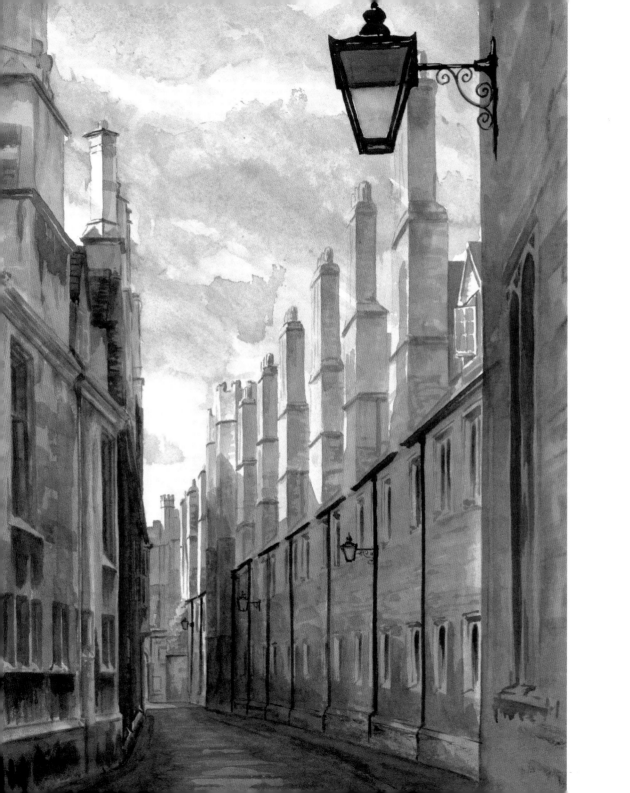

>

39. *Shadows in Caius* (20 × 13 inches)
Gonville & Caius College.
From the north end of Tree Court,
the 16th century entrance to Caius
Court can be seen behind the 1870
apse of the chapel.

>>

40. *Cambridge University Press Bookshop*
(20 × 24 inches)
Cambridge University Press
bookshop and the Senate House.
From Market Street, the bookshop
to the right is the oldest in the
country (selling books since 1581)
and is faced by James Gibbs's Senate
House, a Classical Baroque structure
of 1722–30.

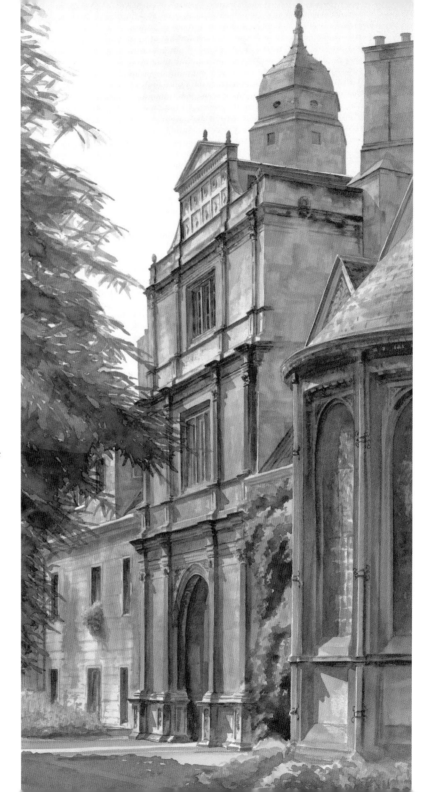

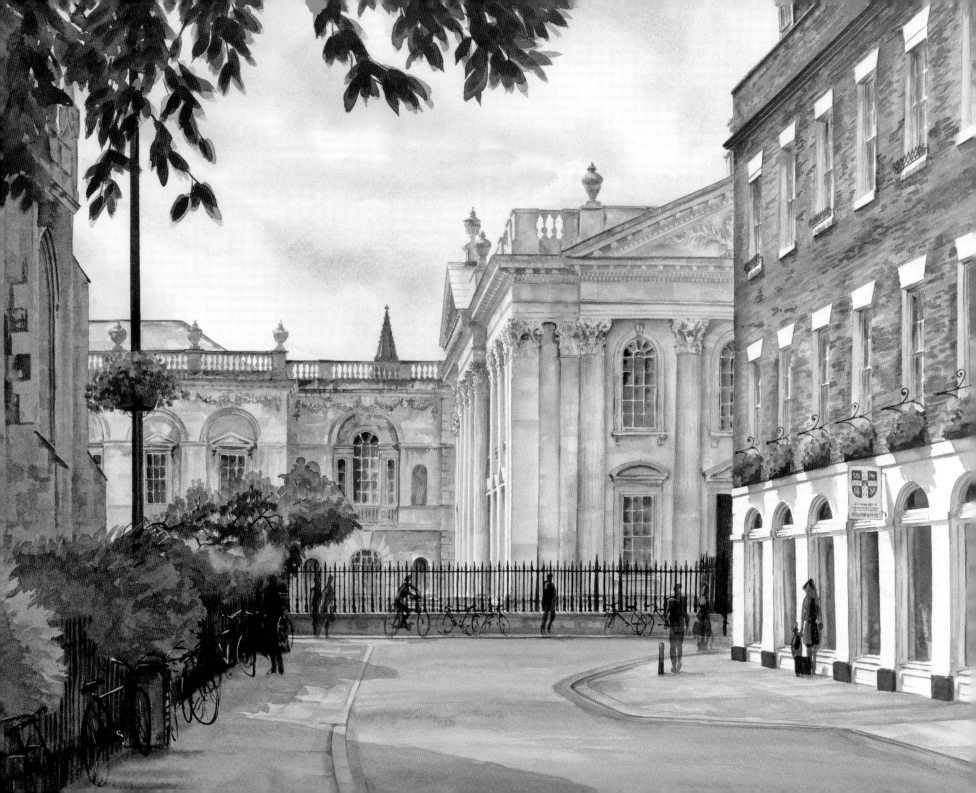

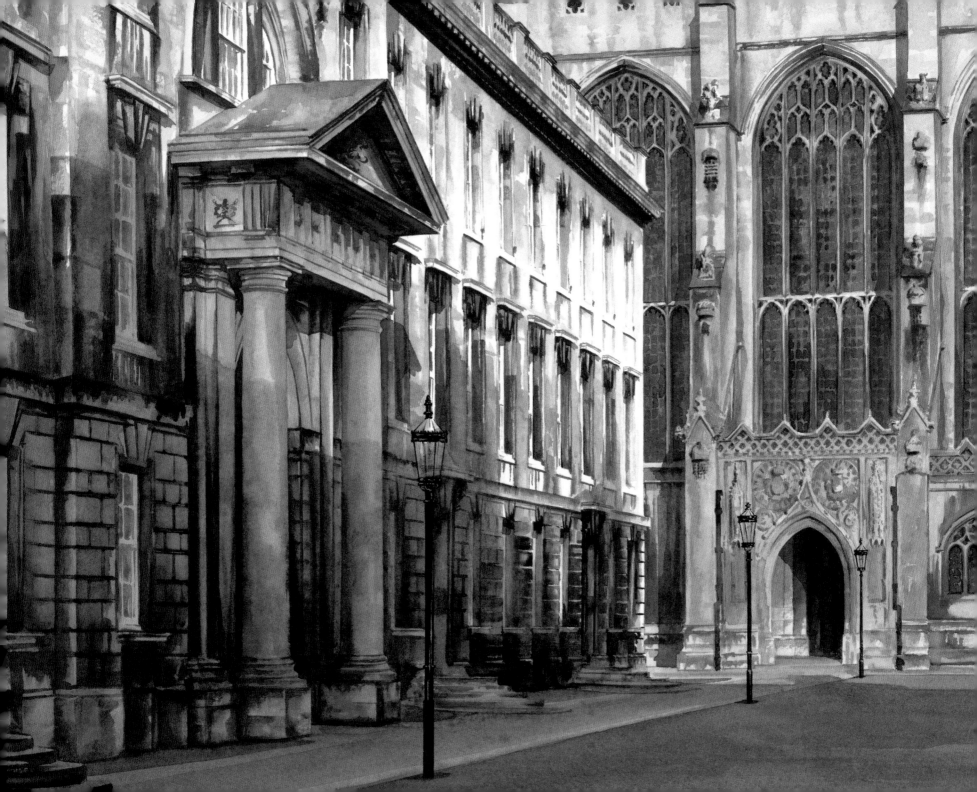

< >

41. *Winter Sun on King's*
(28 × 20 inches)
King's College.
From the south end of Front Court,
winter sun casts long shadows
down the Gibbs' Building of 1724–32
to the south porch of the Chapel
that was constructed between
1446 and 1515.

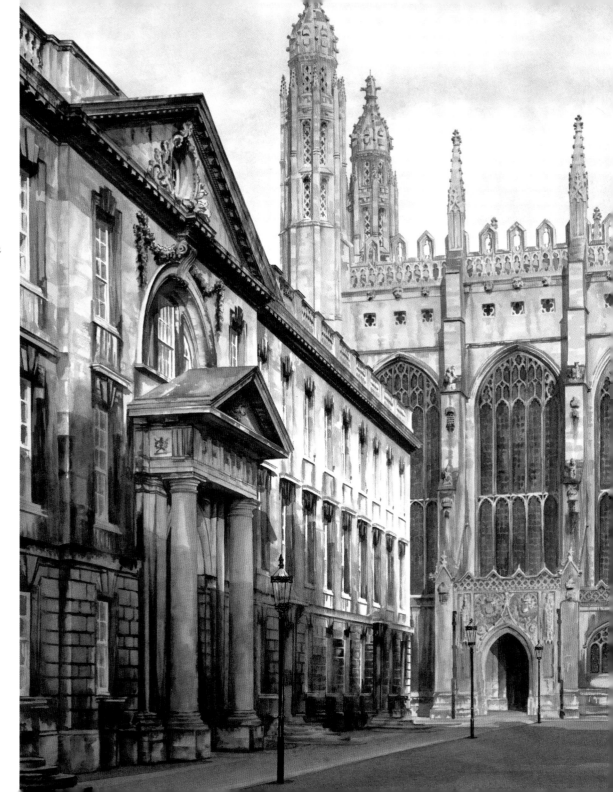

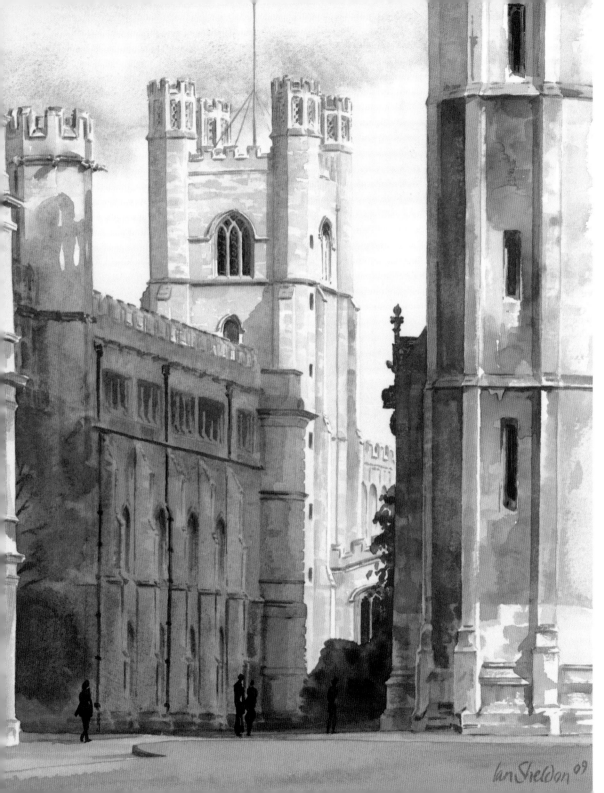

<

42. *Great St. Mary's Tower* (9½ × 9½ inches)
Great St. Mary's Church.
A look from near the river, past
Clare College and King's College Chapel
casting its shadow over the Old Schools,
reveals the tower of the church from
which bells were first heard in 1596.

>

43. *Clare College Shadows* (15 × 27½ inches)
Clare College.
Shadows define the architectural details
of the east range of Old Court dating
from 1638–41.

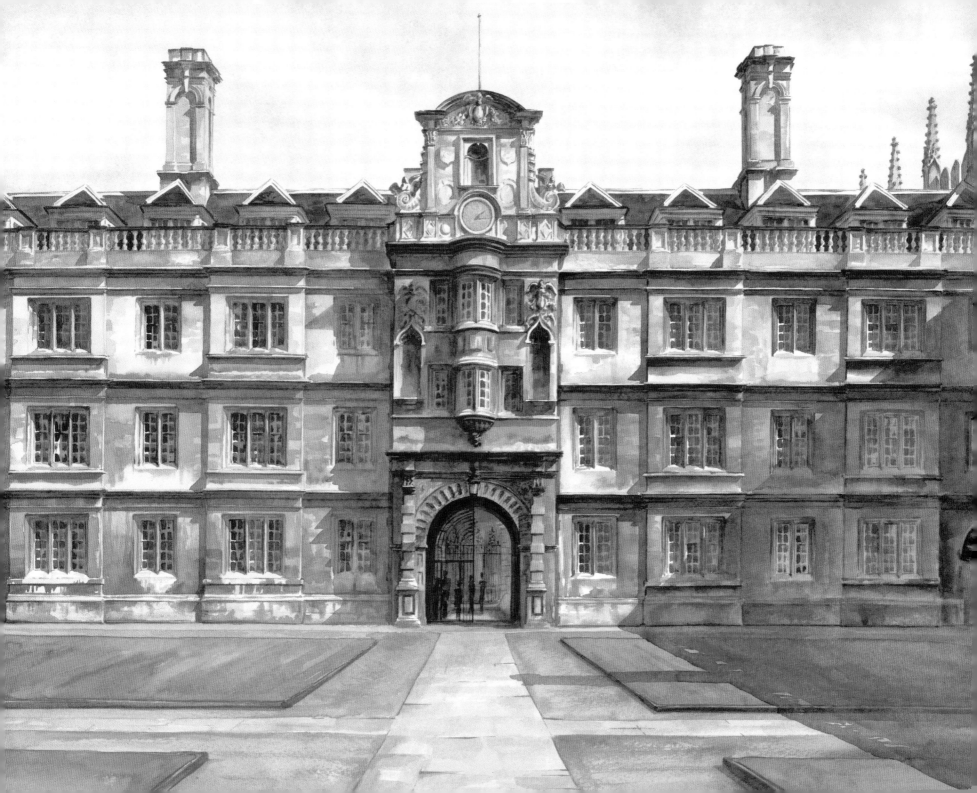

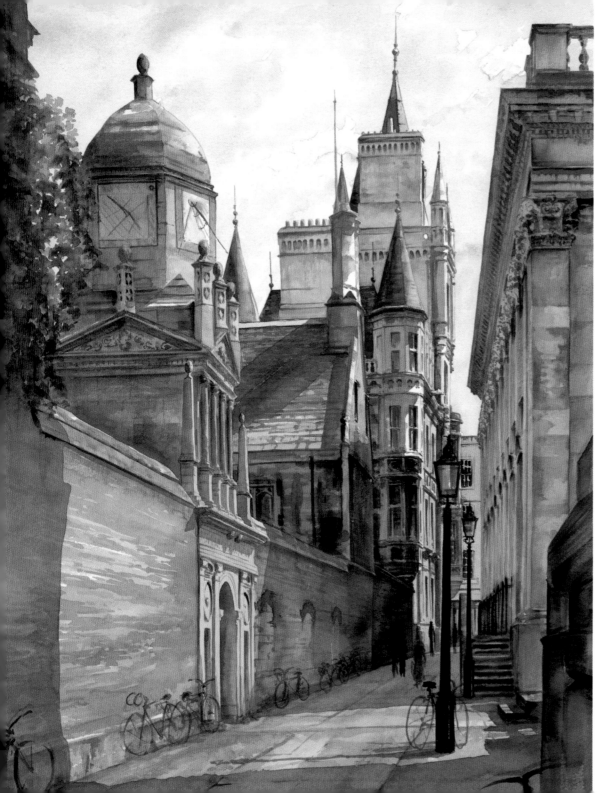

<

44. *Senate House Passage* (20 × 15 inches)
Senate House Passage.
Seen from Trinity Lane, this quiet
passageway for cyclists and pedestrians
boasts Gonville & Caius College's Gate
of Honour (1573–75) on the left and the
Senate House (1722–30) to the right.

>

45. *Trinity Hall* (14 × 14 inches)
Trinity Hall.
Looking from Latham Lawn near the
river, the west face of Main Court can
be seen beyond the Elizabethan Library,
dating from circa 1590.

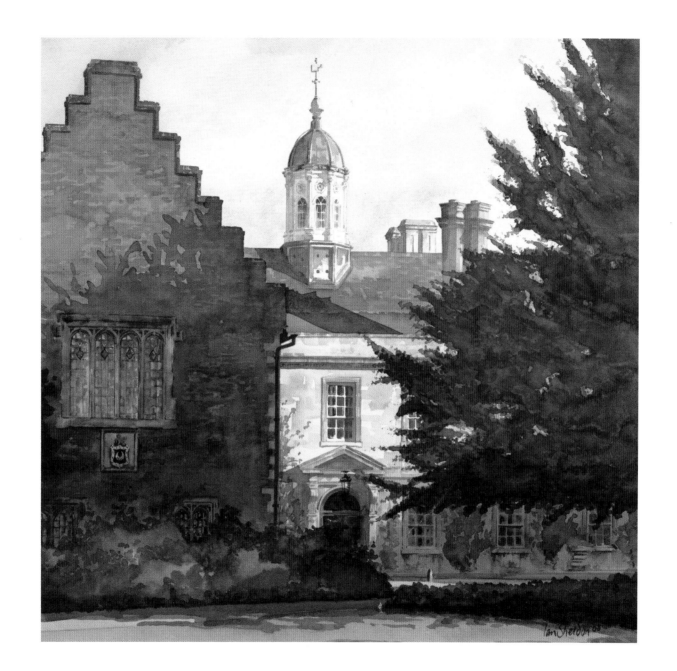

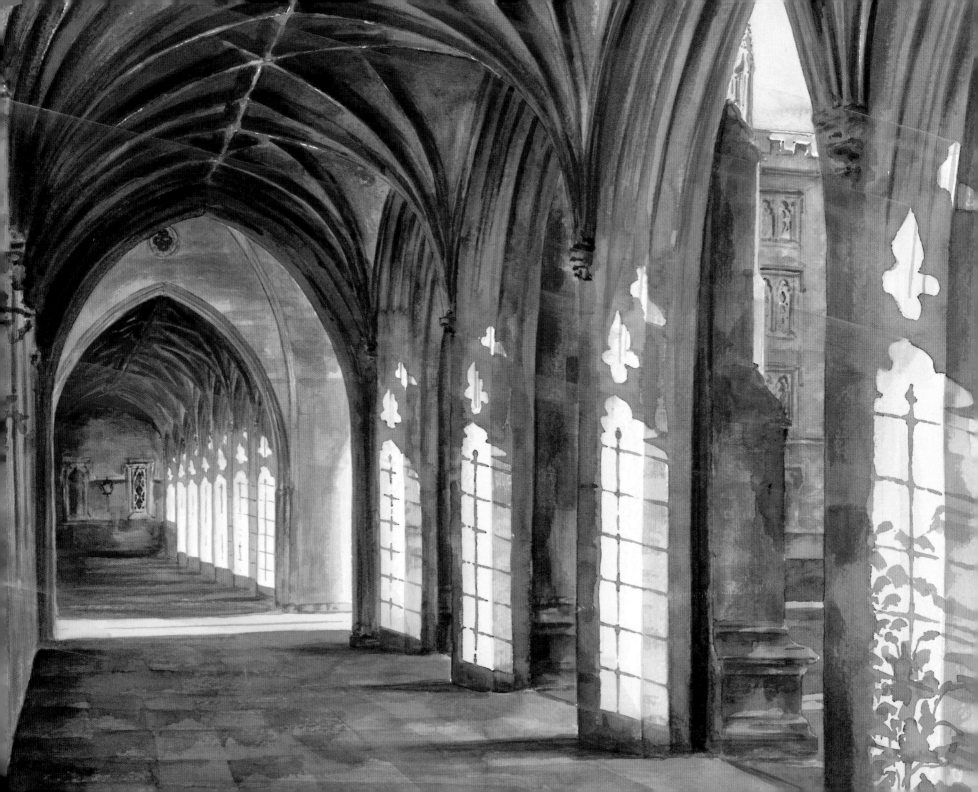

<

46. *Light in the Arches* (13 × 20 inches)
St. John's College.
Sunlight inspires a view down the
length of the cloistered walkway
of New Court, a Gothic Revival
building of 1826–31.

>

47. *Bridge of Sighs* (21 × 15 inches)
St. John's College.
Looking from Third Court to New
Court, Henry Hutchinson's 1831
creation of the Bridge of Sighs spans
the river, linking the west and east
buildings of the College.

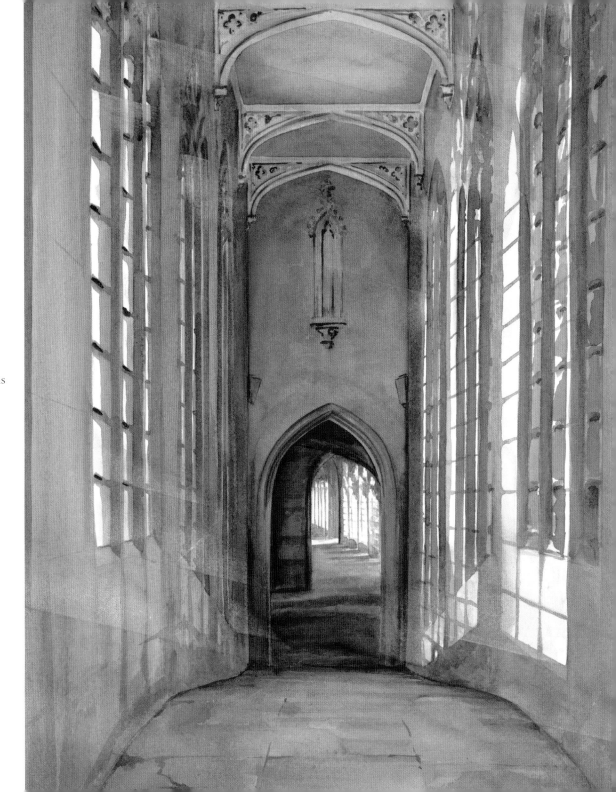

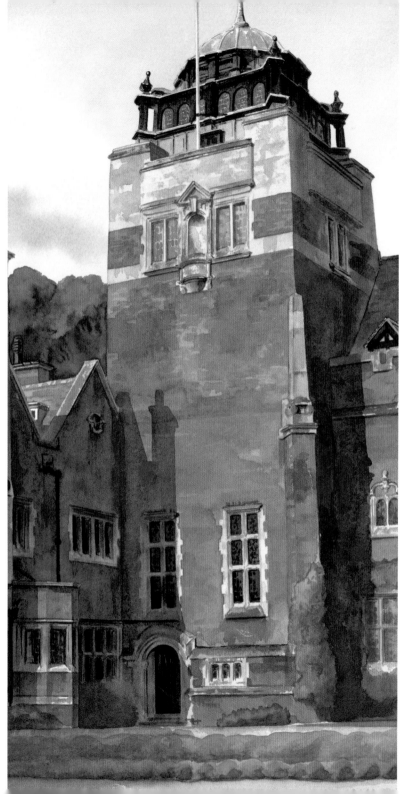

<
48. *Westminster College* (14 × 9 inches)
Westminster College
The Tudor-influenced tower of 1899
by E. T. Hare is a landmark from the
Madingley Road and Northampton
Street roundabout.

>
49. *Lines in Lucy Cavendish* (11 × 11 inches)
Lucy Cavendish.
Seen from Lady Margaret Road, the
2005 extension created a Porter's Lodge
and fused the lines of the late 19th and
late 20th century buildings that make
up the College.

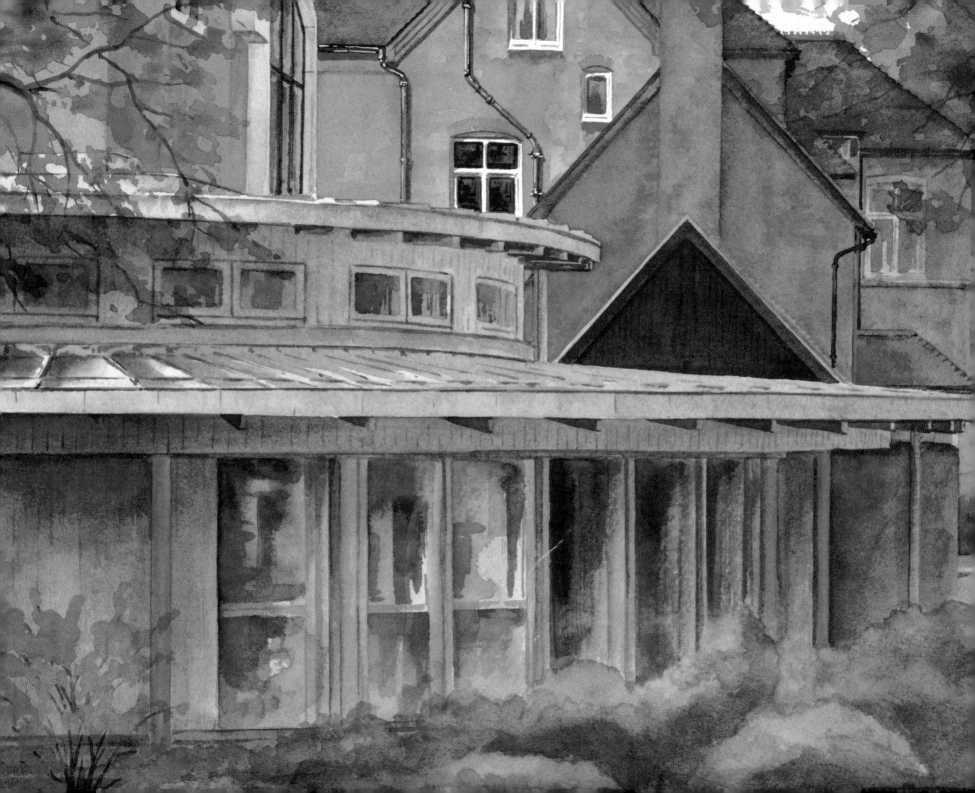

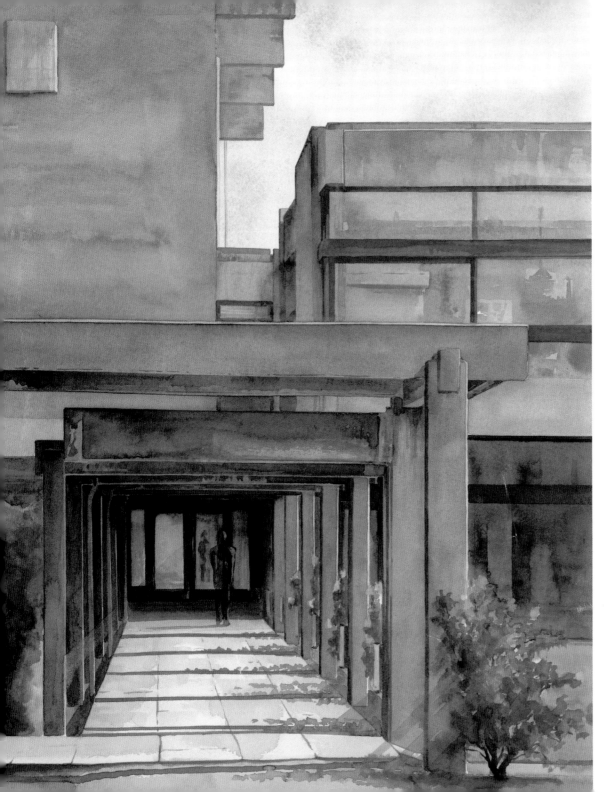

<
50. *Churchill* (18 × 13 inches)
Churchill College.
A covered walkway to the West
Door captures some of Richard
Sheppard's design that was executed
from 1959–68.

>
51. *The Observatory* (9 × 12 inches)
The Observatory.
The Doric columns of John
Clement Mead's 1822–23 building
are just part of the hidden gem that
can be found at the end of a quiet
tree-lined lane off Madingley Road
on the way out of the city.

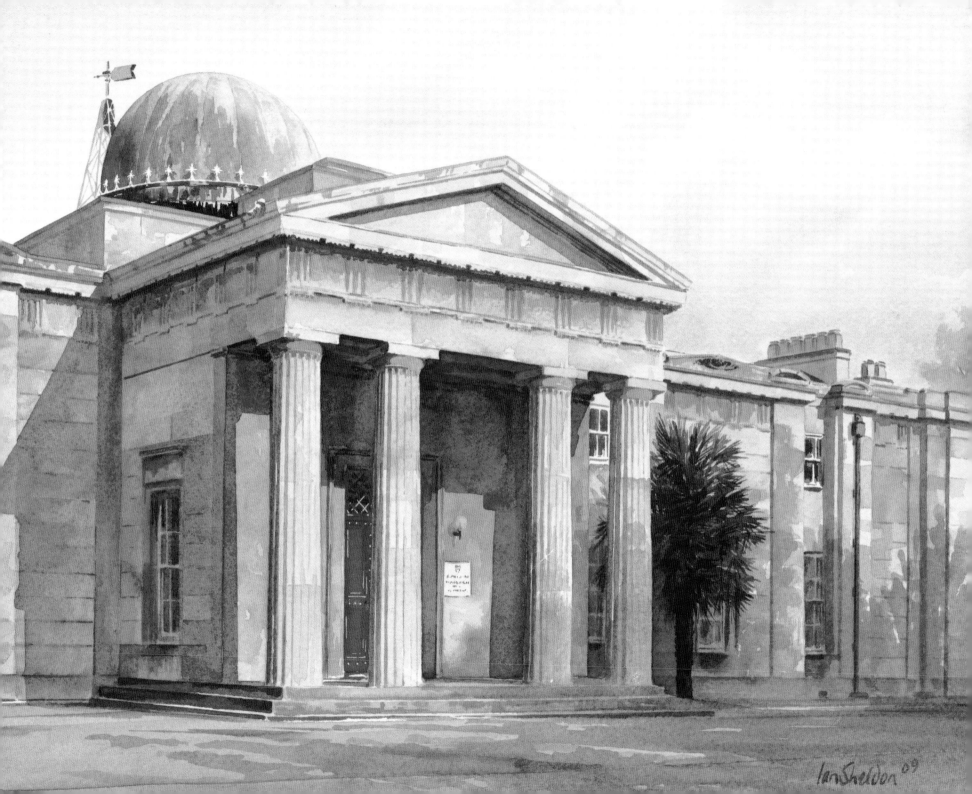

Ian Sheldon '09

ACKNOWLEDGEMENTS

I would like to express my deepest thanks to Stephen Bourne, ever encouraging of
my creative endeavours. It has also been a pleasure to work with
the creative genius of Phil Treble, Stephanie Thelwell and Tim Oliver,
and for their skills I am deeply appreciative.
I am honoured that Duncan Robinson has so kindly provided the foreword.

I am indebted to my collectors and supporters across three continents.
These include Stephen & Stephanie Bourne, Vera Chambers,
Robert de Chazal & Linda Trimble, Nicola Guise & Alasdair Stewart, Helen Ibach,
Terry Krause & Liz Simpson, Alexander & Colette McGuckin, Christopher Michel-Viret,
Jeremy Mynott, Zlatko Pozeg & Candice Schreiber, Heather & John Raybould, Margaret Tribe,
Matt Walpole & Kerry Lutkin, Michael Webb, and Steve & Buffie Wilson.

In Edmonton I was blessed to have worked with Ken Colwill, Alicia Blaine and Anne Leth
at Elite Lithographers Co. Ltd. and thank them for their digital skills, professionalism and generosity.
I am also grateful to the Edmonton Arts Council who generously supported the seeds
of this project, and for recognizing the potential in me.

Lastly I would like to acknowledge the enduring support and faith of my family
Molly, Mike, Roger & Katherine.